IMAGES
of America

ROCHESTER

MINNESOTA

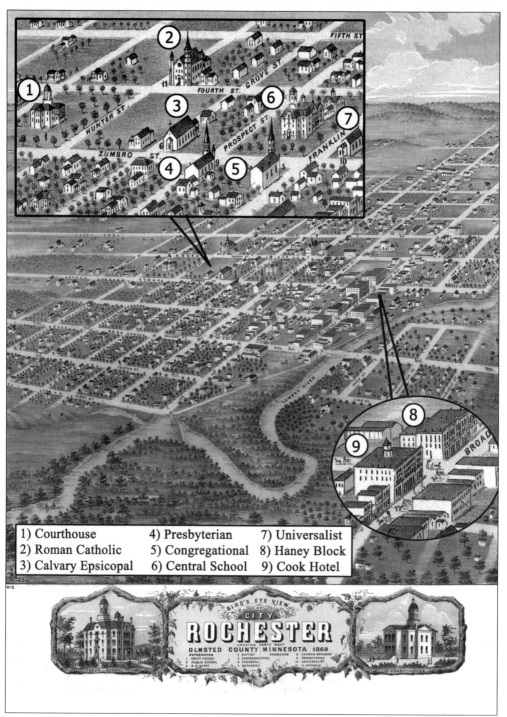

1) Courthouse 4) Presbyterian 7) Universalist
2) Roman Catholic 5) Congregational 8) Haney Block
3) Calvary Epsicopal 6) Central School 9) Cook Hotel

1869 MAP OF ROCHESTER.

IMAGES
of America

ROCHESTER

MINNESOTA

Ted St. Mane

ARCADIA

Copyright © 2003 by Ted St. Mane.
ISBN 0-7385-3150-2

Published by Arcadia Publishing,
an imprint of Tempus Publishing, Inc.
Charleston SC, Chicago, Portsmouth NH,
San Francisco

Printed in Great Britain.

Library of Congress Catalog Card Number: 2003108755.

For all general information contact Arcadia Publishing at:
Telephone 843-853-2070
Fax 843-853-0044
E-Mail sales@arcadiapublishing.com
For customer service and orders:
Toll-Free 1-888-313-2665

Visit us on the internet at http://www.arcadiapublishing.com

CONTENTS

ACKNOWLEDGMENTS

The author would like to gratefully acknowledge the assistance of the many people who contributed information and shared resources to make this book possible. Among them are Alan Calavano, Peter McConahey, Jeff St. Mane, John Hunziker, Sherry Sweetman, the staff and volunteers of the Olmsted County Historical Society, Pete Bennett, Mike Szuberski, the Rev. Diane Harvey, Todd Key, Chuck St. Mane, and Ron Hanson.

The photographs in this book were graciously loaned from the collection of the Olmsted County Historical Society, and from the private collections of the following individuals; Randy Collins, Jim Buzza, Peter McConahey, Alan Calavano, and Jack Key. Additional images came from the private collection of the author.

Also instrumental in the development of this book was the extensive assistance given by Yeleana St. Mane, Sergei Zhiganov, Mike Pruett and MLT Group of Rochester. It is also appropriate to note that histories such as this one would be impossible if not for the now historical documents recorded as current events by a long succession of newspapers, and without the work of organizations such as the Olmsted County Historical Society, the Minnesota Historical Society, the Library of Congress and numerous other custodians of our collective past.

Images loaned by the Olmsted County Historical Society appear on the following pages (T = top, B = bottom). 11, 16, 18B, 19T&B, 20T&B, 21B, 22B, 23B, 37, 39, 40T, 41, 42T&B, 43, 44, 45T&B, 46T&B, 47T&B, 48T&B, 49T&B, 51T, 52B, 54T&B, 55, 57, 58T, 59T, 60T, 63T&B, 67, 73, 75T, 76T&B, 82, 83T&B, 84T&B, 85T&B, 86T, 87, 88B, 92, 93, 96, 98B, 100T, 102T&B, 103, 104T&B, 105T&B, 107T&B, 109T, 110, 112T, 115, 116B, 119B, 120B, 121, 122B, 123, 124B, 125T, 126, 127T&B.

INTRODUCTION

In 1869 *The Minnesota Guide*, a handbook of information for travelers, pleasure seekers and immigrants, described Rochester, Minnesota as "a fine business point" with a population of 4,500 "and growing rapidly." Designed to entice settlers to the area, the guide further stated of the young city, "It is neatly and handsomely built, many of the buildings being of brick, and very substantial. There are several fine churches, two or three hotels and a number of stores, many of them first class."

Today Rochester boasts over 60 hotels, motels or guest houses and is renowned not only as a fine business point but also as a world class medical center, a technology town and a city of such favorable charms and amenities that it has been repeatedly recognized by *Money Magazine* as "the best place to live in America."

During an earlier chapter of America's history the Ojibwa (Chippewa), Dakota (Sioux) and Winnebago were among the native peoples who made their homes on the vast prairies, a part of which Rochester now occupies. These Native Americans trapped, hunted and traveled along the winding river that the Dakota called Wazi Oju, or "Pine Clad." The French claimed this region from the mid-1600s to the mid-1700s, developing a robust fur trade. During this time someone among the French explorers and fur traders gave the river the unappreciative name Les Ambras, meaning "the embarrassment." On May 2, 1803, the area destined to become Rochester, Minnesota fell under control of the United States Government when the Louisiana Purchase secured a vast area of land west of the Mississippi for the growing nation. French influence receded and in time the little river that runs through Rochester became known as the more Anglo sounding Zumbro River.

In 1851 the United States forced the treaties of Mendota and Traverse des Sioux upon the Chippewa and the Dakota, depriving these Native American tribes of their ancestral lands and confining them to reservations—thus opening the area for settlement while planting the seeds for future unrest. Convinced that a better life could be had in the Minnesota Territory, a stream of adventurous souls came west through the Zumbro valley and a camping ground and crossroads of settlers developed on the site where Rochester now stands.

The first legitimate land claims at the site were made by Robert McReady and Thomas Cummings in what is now western Rochester, but the city owes its name to George and Henrietta Head. Originally from Rochester, New York, George and Henrietta had traveled from Waukesha, Wisconsin with George's father, John Head, and brother Jonathan Head. On July 12, 1854, they laid claim to land situated along the West side of the Zumbro River in what is now downtown Rochester. The family built a log cabin on a spot of prairie that is today the intersection of Broadway Avenue and Fourth Street. Their humble dwelling became a refuge

for many a frontier traveler and was known as Head's Tavern. It is reported that the couple named the fledgling community after Rochester, New York because the sound of the falls on the Zumbro River reminded them of that city.

In that same summer of 1854 the M.O. Walker Stage Line began service along the Old Dubuque Trail between St. Paul and Dubuque, Iowa, with a stop at the Rochester crossroads. An important pathway of commerce, the Dubuque Trail was Rochester's primary link to outside markets and a catalyst for travel to and through the little town. By 1856, two years after the Head Tavern was established, Rochester had grown to a modest population of 50 citizens, but a boom was in the making and the next two years saw the town's population mushroom to more than 1,500!

Minnesota became the 32nd state admitted into the Union on MAY 11, 1858 and Rochester was incorporated in the recently formed County of Olmsted on August 5 of the same year. Rochester was already the county seat, having been established as such a year earlier in a disputed vote, which secured it the honor over Marion and Oronoco. Also of note in 1858 was the gold rush to the area set off by the discovery of gold in the Zumbro River at both Rochester and Oronoco. The rush was short lived however as the quantity of gold uncovered did not measure well against the expense of extracting it.

With the outbreak of the American Civil War on April 12, 1861 the citizens of Rochester were drawn into the greatest period of internal strife the country has ever known. The new state of Minnesota was the first to respond to a call for volunteers when Governor Alexander Ramsey offered President Lincoln one thousand men to help defend the Union on April 14, the day news of the attack on Fort Sumter reached Washington, D.C. During the course of the war more than 1,200 Olmsted County men left their homes to join the fight. Many never returned. While Union and Confederate armies never clashed over Minnesotan ground, another bloody war did sow destruction across much of the state not far from Rochester. From August to December of 1862 the Dakota tribe rose up against the non-native settlers in a whirlwind campaign that history has long referred to as the Great Sioux Uprising. In less than one week nearly 500 settlers were killed, several million dollars' worth of property destroyed and tens of thousands rendered homeless. The city of New Ulm, just 115 miles from Rochester, was attacked twice and nearly all of its 200 plus buildings burned, giving sufficient cause for residents of Rochester to fear for their own safety. Dr. W.W. Mayo, who was then in New Ulm, established a hospital in New Ulm's Dacotah House to care for victims of the attack.

Soldiers from Rochester attached to Co. F of the Ninth Regiment of Minnesota Volunteers fought against the forces of Chief Little Crow at Wood Lake. A writer of the time mourned not only the many lives lost but also the ill treatment that led to the horrific conflict, "Is it not possible that by fair and manly dealing with them [the Dakota], by a just trade, and conscientious regard for the sanctity of treaty rights and obligations that we might so win their good will as to make them friends instead of enemies? The devil that lies at the bottom of all savage natures is easily roused, not at all so easily laid again."

In 1864, while soldiers from Rochester still struggled alongside their comrades in the wasteful battlefields of Kenesaw Mountain and Atlanta, Georgia, Rochester welcomed the arrival of the Winona and St. Peter Railroad, an important development that linked the city to the Mississippi via Winona. The railroad meant that wheat and other commodities could be shipped faster and more cheaply to distant markets. Today the 54-mile trip from Rochester to Winona can be easily accomplished in just one hour, but prior to 1864 the perils of the imposing bluffs and valleys separating Rochester from the Mississippi to the east were sufficient to force settlers in the Rochester area to send their goods by wagon along the much longer Dubuque Trail.

Another Civil War era event important to Rochester's future was the arrival of Dr. William Worrall Mayo. Mayo was born near Manchester, England and had immigrated to the United States in 1845. In 1863 he was appointed an examining surgeon for the first Minnesota district of the Union Army enrollment board. The board was headquartered in Rochester and Dr. Mayo

moved his family to the city in 1864. Following the war Dr. Mayo's two sons, William and Charlie, joined him in his medical practice. First as observers and assistants and later as fully accredited medical doctors.

In 1883, the same year William J. Mayo graduated from the University of Michigan Medical School, a killer tornado descended on Rochester ravaging the city. In the aftermath temporary hospital quarters were established and the Sisters of Saint Francis, a local order of Nuns, joined with area doctors and volunteer nurses in caring for the many injured. Touched by the disaster the Sisters of Saint Francis initiated efforts to raise money for the construction of a hospital. The Doctors Mayo were persuaded to enter into an agreement whereby the Sisters would build and maintain the facility and the Mayos would provide a medical staff. Their combined efforts resulted in the opening in 1889 of Saint Marys Hospital, the first general hospital in southeastern Minnesota.

Throughout the 1880s farming remained the area's chief industry while tourism continued to grow. The latter was largely driven by a general notion in the East that the bracing Northern climate had healthful, restorative powers. Certainly Minnesota publications had long been happy to lend credence to this perception. Writing for a *History of the County of Olmsted* in 1866, W.H. Mitchell described the effects of the area's cold winters on Eastern visitors, "They inhale the fresh and invigorating atmosphere, with its life-giving elements, and their lungs expand and grow strong under the influence of such inhalation. Their nerves are braced up to healthier action." He concluded his assessment with the words, "As a healthy state, Minnesota is not excelled by any in the Union."

As the Twentieth Century neared, the farmers around Rochester experienced more than just the advent of the machine age. The 1890s saw the end of bountiful wheat harvests throughout the area as the soil became depleted. Wheat farmers were forced to turn to corn, hay, oats, hogs and cattle. Dairying also became popular as an economic niche in an agricultural economy that was becoming more and more specialized.

By 1905, Rochester had grown to a population of 7,233. Horse teams shared the streets with new fangled automobiles and the suffragette movement, though still more than a decade away from securing the vote for Rochester's women, was gaining ground. It was a time of rapid change and the city grew and prospered during the quiet years preceding the First World War. World War I may have had as great an impact on the community as the War Between the States. Numerous Rochester natives contributed to the victory in Europe and again the community suffered painful losses. November 11, 1918, the day news of the war's end reached Rochester, was a day of spontaneous and widespread celebration. The Rochester Daily Bulletin reported that starting at three in the morning "the big whistle on the power plant boomed out" to rouse the populace with the grand news.

The 1920s saw continued growth throughout the city including the construction of the Mayo Clinic's Plummer Building in 1928, a structure that dramatically changed Rochester's skyline and marked the coming of age of a great medical institution. The age of the aeroplane had also arrived and Rochester became home to two airfields, Graham Field and Lobb Field. Both were later abandoned in favor of the current International Airport location south of the city.

The boisterous twenties ended in calamity with the stock market crash of 1929 and Rochester, like the rest of the country, struggled through a decade of economic depression. Banks failed and businesses closed. Shortly after taking office, President Franklin D. Roosevelt initiated the "New Deal" promoting a wide array of programs and policies to stimulate the economy and put the country back to work. These programs were responsible for the creation of water conservation projects and improvements to roads and recreational sites throughout this area. Rochester's citizens got a first hand look at the charismatic President when he visited Rochester on August 8, 1934, and again in September of 1938.

Following the shocking events of December 7, 1941, the citizens of Rochester listened transfixed by their radios as FDR declared, "No matter how long it may take us to overcome this premeditated invasion, the American people in their righteous might will win through to

absolute victory." America had been drawn into World War II. This time Rochester contributed more than its young men and women to the war effort. Ground breaking medical research conducted by the Mayo Clinic not only enhanced medical care for wounded soldiers but also brought about important advances in aviation technology, including a pressurized garment to prevent pilots from experiencing blackouts during extreme aerial maneuvers.

Franklin Roosevelt never saw the victory he helped insure and it was a new Chief Executive, President Truman, who came to Rochester on October 14, 1948, with an affirmation for the city that had grown into a great medical center. "Thousands and thousands of Americans, distinguished Americans and plain citizens, have come to this great city to recover their health," said Truman. "I wish the whole nation could have the opportunity to enjoy the kind of medical care that is available here in Rochester, Minnesota."

Not only medicine flourished in Rochester. In 1956 IBM established a manufacturing and research facility here that was the catalysis for expansive computer science and technology growth within the community. Agriculture remained important to the area but for Rochester itself an extensive service industry provided much of the city's economic strength throughout the mid-to-late 1900s. Today Rochester boasts a wide variety of businesses and a diverse population. The city has grown to over 85,000 inhabitants and yet retains much of the friendly small town atmosphere that it enjoyed in the 1800s.

A strong economy, an excellent educational base, outstanding community services and numerous arts opportunities combine with a healthy environment and a beautiful, peaceful setting to make Rochester one of the best cities in America to call home.

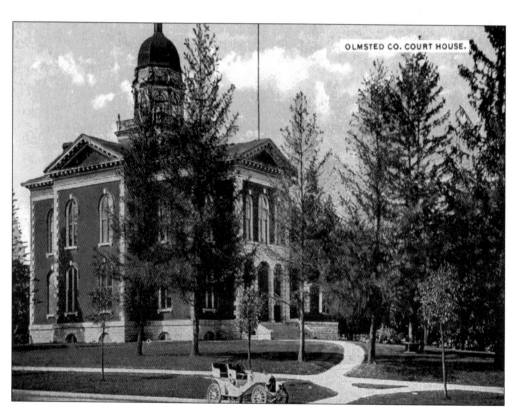

OLMSTED CO. COURT HOUSE.

One

EARLY YEARS
1854–1882

Between 1854 and 1882 thousands of settlers, adventurers and entrepreneurs streamed into Minnesota lured by promises of land, opportunity and a healthful climate that the *Rochester Democrat* of 1858 claimed was, "unequaled—in summer as well as winter." No roads, bridges or signposts greeted the advancing wagons. The settlers literally made their own roads, built their own homes and dug their own wells. Some stayed only briefly before heading further west, but others put down roots and commenced the hard work of building up communities on the lonely prairie. Given the enormity of the challenges confronting these early settlers it is amazing that they accomplished so much so quickly. By 1869, just 15 short years after the first shanties were erected on the site, Rochester was a bustling community of 4,500 inhabitants served by two stage lines and a railroad. The city was home to several churches and hotels, as well as many well-stocked stores and fine private residences. *The Minnesota Guide* noted Rochester's growth in 1869 calling it "one of the principal cities in the State." The publication further reported, "One business block, costing $60,000, has recently been built, and a court costing nearly $40,000. A central school is also built, four stories high, costing $56,000. A large trade is carried on with the surrounding country, which is well settled, and with neighboring towns. Large quantities of wheat are marketed here, and considerable is ground up in the three flouring mills. The Zumbro River furnishes sufficient waterpower and considerable manufacturing is carried on. There are two good seminaries, a library association and a national bank company."

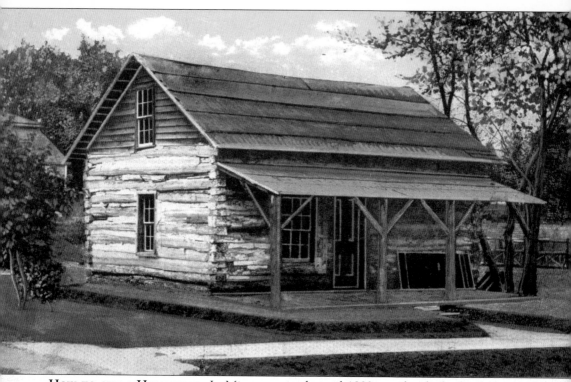

HOW TO GET A HOMESTEAD. In Minnesota in the mid-1800s any head of a family, or single man 21 years of age, could obtain 160 acres of public land by paying twelve dollars for it at the local U.S. Land Office with title perfect at the end of five years. During the five years the settler must, in good faith, "inhabit" and "cultivate" the tract. Problems cropped up when settlers ventured off their property. A claim holder, who left to collect family in the east or even just to pilgrimage to another city for supplies, might return to find his dwelling occupied or torn down by unscrupulous claim jumpers. The problem was so rampant in the early years that a committee of able-bodied Rochester men known as "The Regulators" was formed to deal with claim disputes as they arose. Even Rochester's acknowledged founder, George Head, is said to have "jumped" the claim of Edward S. Smith. Smith and a group of partners staked a claim and established a cabin in the vicinity of what would later be Broadway Avenue and Third Street SE, which he held until July of 1854 when George and Jonathan Head arrived at the spot and promptly set about destroying the cabin. Smith returned before the destruction was complete and chased the Head's off the property at gunpoint. The issue was settled when Head paid Smith for his claim. Pictured is the Rochester pioneer cabin of William Dee built in 1862 and currently preserved and displayed on the grounds of the Olmsted County History Center.

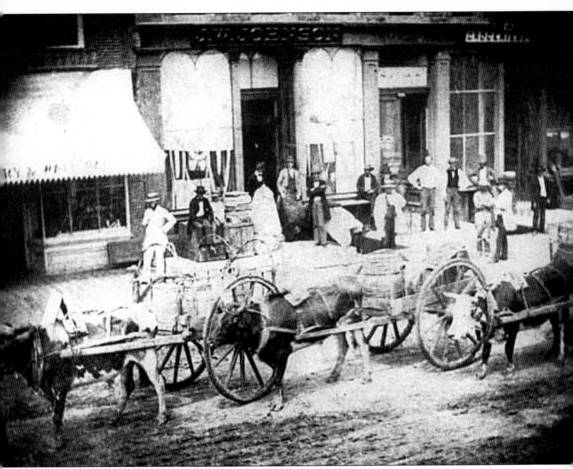

BUILDING A FRONTIER CITY. Local legend relates that Rochester's first street was initiated in 1854 by employing an oxen team, similar to those pictured, to drag a log down what was to become Broadway Avenue in order to clear brush. Two years later Rochester's first bridge over the Zumbro River was built. Prior to 1856, "travelers forded the river on the stone bottom above the falls and went up the west bank by a narrow track." According to Charles C. Wilson's eye-witness account, the first bridge "consisted of three stringers about 30 feet long, one end resting on the west bank some three feet above the water at ordinary stages with a dug-way along and up the bank. The east end of the stringers rested on a big log. Poles were laid across these stringers and prairie hay and sod were put on these poles, and the whole weighted down with stones taken from the river bottom." This bridge was washed away the next spring and a more permanent structure with stone piers was built in the summer of 1857. In 1858 the city was forced to pass an ordinance barring the removal of "sand, gravel or earth from any street, alley or highway in the city." Apparently the city's very roadways were in danger of being scooped up for private building projects. In 1859 a survey and "profile of the grades of Broadway" was undertaken by R.P. Condit and the first pavement was laid on Broadway soon after. Prior to this time the avenue had been impassable following heavy rains.

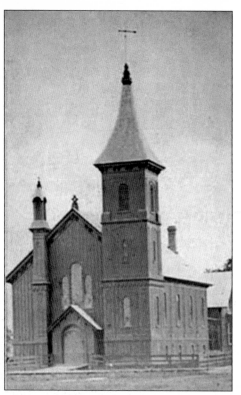

ROCHESTER'S PRESBYTERIAN CHURCH, 1865. Reacting to the soul searching of civil war, a Presbyterian minister of the day counseled, "War is not an unmitigated evil, terrible as its ravages are. It is like the hurricane in nature, desolating and terrific, yet accomplishing ends that can be accomplished by no other agencies. The brooding miasma, the tainted air and the poisoned water are swept away, and there are left behind a purer air and a richer soil than could have existed without this purgation of tempest. Similar services are rendered by the hurricane of war, in spite of its evils."

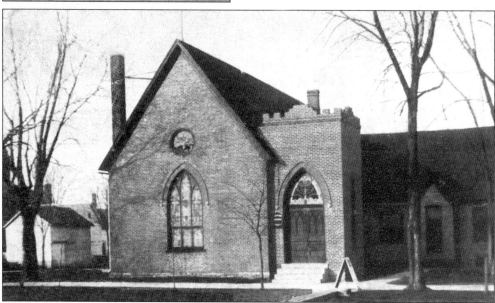

ROCHESTER'S OLDEST SURVIVING CHURCH. In 1863 the congregation of Calvary Episcopal built on land donated by city founder George Head. The original structure, built in the Gothic style with locally made bricks, remains the core of the present-day church. From 1860 to 1863 the congregation had held services in various locations around Rochester. Calvary's first rector, the Rev. Charles Woodward, diligently saw to his flock's musical needs by carrying a "melodeon" to wherever services had been scheduled for that week.

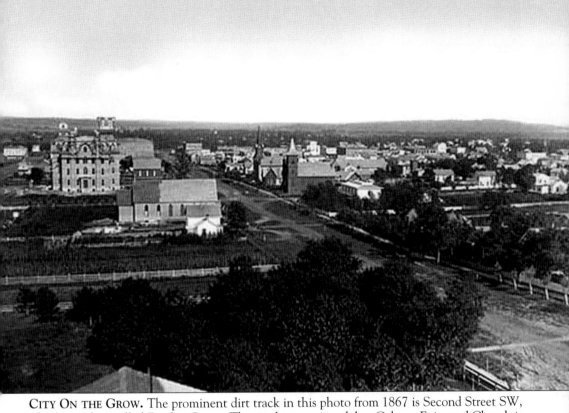

CITY ON THE GROW. The prominent dirt track in this photo from 1867 is Second Street SW, which was then called Zumbro Street. The single story, steepleless Calvary Episcopal Church is at left center with the Central High School just above it. Note the unfinished tower on the new school. Across Second Street are the Presbyterian Church, with a light colored steeple roof, and the Congregational Church. Rochester enjoyed rapid growth through much of its first decade. By 1865 the city directory listed more than 75 businesses, including three banks, six blacksmiths, twelve dry goods stores, four implement dealers, three billiard halls, eleven attorneys and one jeweler. Along with progress came growing pains and the young city was faced with problems common to municipalities the world over. In 1867 an ordinance was enacted prohibiting the keeping of "houses of ill-fame," defined as any dwelling wherein was committed "any immoral, immodest, or other improper conduct or behavior, or any tippling, reveling, rioting or disturbances." Those failing to refrain from tippling or other of these unseemly activities were subject to a fine of not more than 100 dollars and up to 30 days in jail. Still, the Rochester of 1865 had not grown so large as to lose all its small town ways. For instance, the *Rochester City Post* published a monthly list of "letters remaining unclaimed in the Post Office at Rochester." People seeing their name listed could claim their mail from Postmaster C.C. Jones after paying the cost of advertisement.

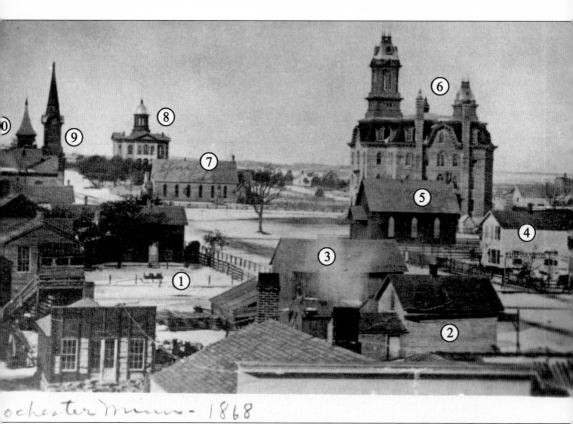

ochester minn - 1868

ROCHESTER'S SKYLINE—1868. This photo from 1868 makes a wonderful guide to early Rochester. Since most of these buildings are no longer in existence to serve as reference points, the structures that succeeded them are also listed here. **1)** Open yard at the corner of First Avenue and Second Street SW, later site of the Rochester Public Library (1898–1948), **2)** Hunley's Cabinet Store, **3)** an old barn that became the site of the Cook Block, later known as the Massey Building (built 1878), **4)** Isaac Simonds' home, currently the east end of the Plummer Building (built 1926–1928), **5)** Original Universalist Church (1866–1877), later site of Grace Universalist Church (1877–1915), currently SW corner of the Plummer Building, **6)** Central High School (1869–1950), current site of the Mayo Clinic Building (constructed 1950–55), **7)** Calvary Episcopal Church (built in 1863) has remained in this location for over 140 years, **8)** Olmsted County Courthouse (1866–1957), later site of a second courthouse that was redeveloped and expanded in 1993 as the Mayo Clinic's Ozmun Building, **9)** Congregational Church (built 1864–1866), later site of a second Congregational Church (1916–1963), currently site of the Mayo Clinic's Hilton Building, **10)** Presbyterian Church (built 1865), later site of the second Rochester Public Library (built 1937), which was converted for use by the Mayo Medical School in 1972.

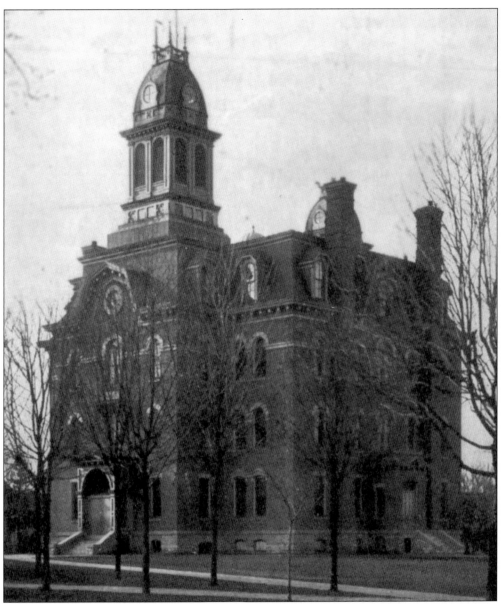

CENTRAL HIGH SCHOOL. Possibly the most impressive school building ever erected in Rochester, the Central High School was built in 1867–68 at a cost of $70,000 with $5,000 spent for a block of property bordered by First and Second Street and Second and Third Avenue SW. One hundred and twenty seven feet tall, the imposing school building was constructed from locally produced bricks, held sixteen classrooms and was heated by gas. By contrast, Rochester's first schoolhouse, established in 1855, was a 20 x 30 foot log cabin housing benches, a teacher's desk, a stove, wood box and one teacher for all grades. This structure was located on the corner of Second Avenue and Fifth Street SE. By 1858 the population of students had become unmanageably large and the basement of the courthouse became a schoolroom. For some years thereafter, additional space was gained by pressing into service vacant barns and storerooms as the need arose. By 1861 a number of "select schools" had sprung up. These were private schools generally consisting of one teacher each.

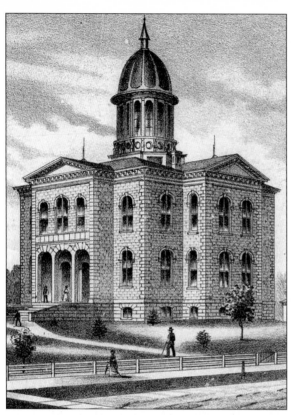

OLMSTED COUNTY COURTHOUSE. In 1857 the Olmsted County Commissioners established the county seat at Rochester and the following year officially organized a county government. From 1858 to 1866 the commissioners met at 301 North Broadway in Charles Lindsley's "rambling" two-story frame building, which later became the Broadway House Hotel. The impressive courthouse illustrated here was built in 1866–67 at a cost of $32,000 and was regarded as the finest courthouse in southeastern Minnesota.

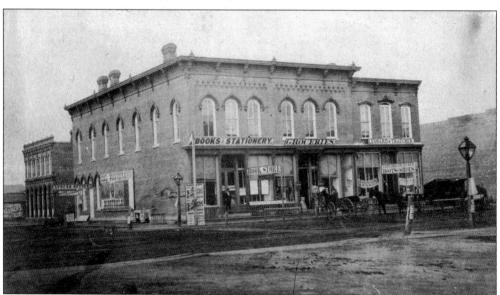

LELAND BLOCK, C. 1870. The Leland block on the northwest corner of Broadway Avenue and Third Street SW housed at least three businesses in 1870. George Leonard operated both the bookstore at left and the Leonard & Thatcher shoe store at right, while H.E. Nelson and Son owned the grocery at center. The Keystone Hotel is seen at left rear. The Leland Block building was razed in 1947 and the Hilton Hotel was built on the site in 1999.

18

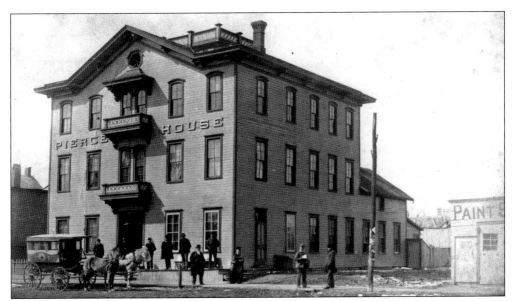

THE PIERCE HOUSE. Opened in August 1877, this hotel was, according to the Rochester Post, "well ventilated and lighted . . . There are transoms over every inside door and every room in the building has from one to three windows. In point of economy of room, as well as in convenience and pleasantness, the plans and arrangements of the Pierce House could hardly be excelled. Every square foot seems to be appropriated to the best advantage, while there is not a single unpleasant, unsightly or inconvenient room in the house." Built by J. Pierce on the site of the former Steven's House hotel at 217-219 First Ave. SW, the building received a brick addition in March of 1880. In March of 1884 the name was changed to the Commercial House, but from February of 1891 to March of 1893 it was again the Pierce House. In March of 1893 the name changed to Grand Union Hotel and in July of 1895 it was remodeled and reopened as the New Rochester Hotel. Eventually the hotel was expanded to the size shown below.

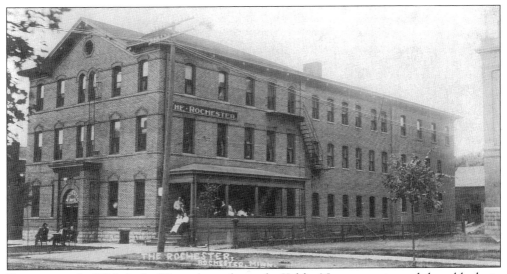

RELOCATED. In 1928 the building, then a home for Kahler Nurses, was moved three blocks to 426 Second Ave. SW and renamed the Maxwell House to make room for the Model Laundry. The 70-room structure was the largest building moved in the city up to that time.

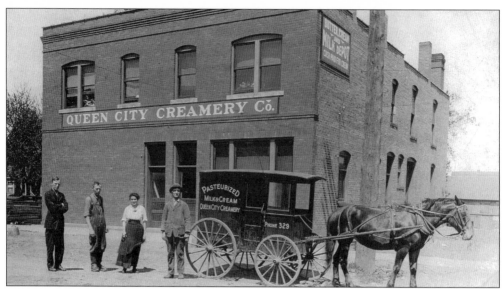

QUEEN CITY? The staff and delivery wagon of the Queen City Creamery is pictured outside their building at 15-17 West Sixth Street. But where does the "Queen City" come from? No one is quite sure, but it seems that Darling's Business College in Rochester, a school for business practice, commercial law, business penmanship and "all the common and higher English branches," adopted the name "Darling's Queen City Business College" sometime prior to 1883, starting a naming trend that extended to several Rochester businesses.

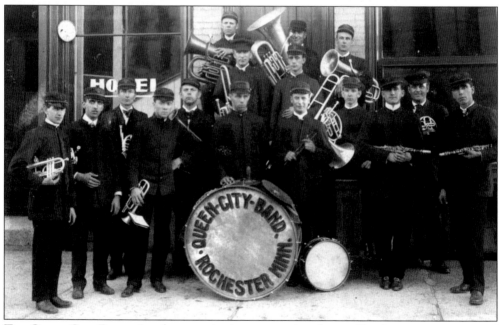

THE QUEEN CITY BAND. Another organization apparently influenced by the naming practices of its neighbors was the Queen City Band. Groups such as this and the Rochester Park Band were common to most area towns and were a vital source of entertainment. These unpaid organizations performed concerts indoors and in the park as well as participating in parades and festivals, and staging special events such as the Masquerade put on in 1883 by the Rochester Cornet Band.

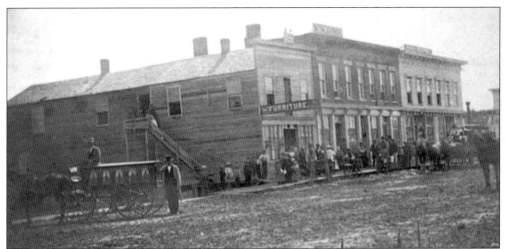

THE CASKET COACH. A horse-drawn hearse pauses on a Rochester street in 1870. During this period cabinetmakers often doubled as coffin makers. Magazines of the day such as *Godey's Ladies Book* and *Harper's Bazaar* carried advice on both clothing and acceptable behavior during mourning. For a spouse mourning generally lasted twelve to thirty months. There were also accepted periods of mourning set forth for parents, siblings, grandparents, cousins, children and even infants.

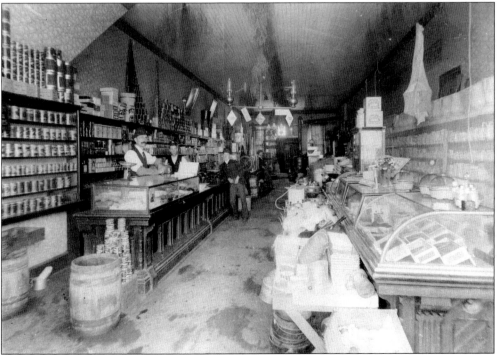

THE CORNER GROCER. Pictured is the Pierce Grocery at 109 South Broadway. J.A. Pierce (left) and Eddie Root are behind the counter. The leaning customer is unidentified. Grocers of the day stocked a wide variety of consumables, often advertising choice "fancy goods" such as oysters or candies. Purchasing on credit was also the norm for many years, so much so that businesses requiring cash for purchases were something of a novelty before 1900.

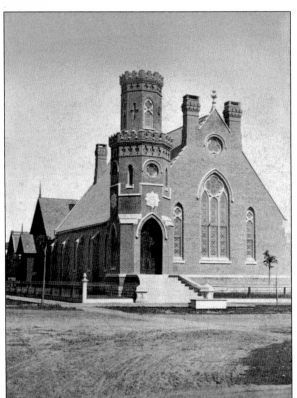

GRACE UNIVERSALIST CHURCH. This striking church was built in 1876–77 at the corner of Second Avenue and Second Street Southwest, replacing a smaller Universalist church constructed on the site in 1866–67. The Reverend Eliza Tupper Wilkes became the church's first female minister in 1869 and in 1889 Rochester's first pipe organ was installed in the building. The site was sold to the Mayo Association in 1915 and is the current site of the Mayo Clinic's Plummer Building.

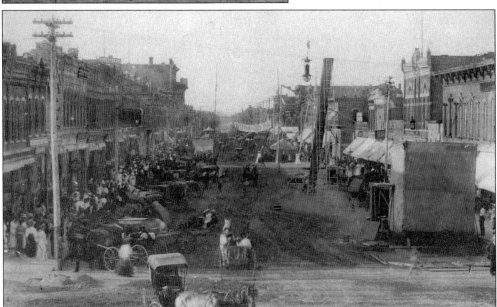

CARNIVAL ON BROADWAY. Rochester has been host to a great many popular traveling shows over the years. Here a carnival is staged in the midst of Broadway Avenue. In 1883 a coming attraction billed as "Van Amburgh, Frost, Stone & Company's Mammoth Menagerie and Circus" promised among its diversions "rare living specimens of nearly all the wild beasts in the world" and "all the champion riders and gymnasts!"

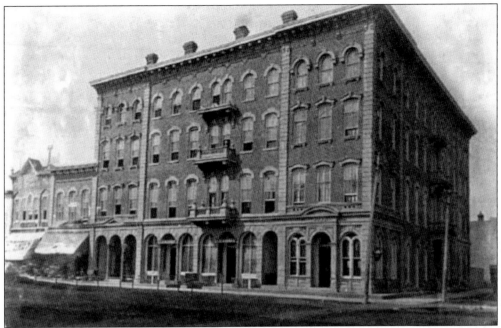

COOK HOTEL. This majestic four-story structure is the Cook Hotel, *c.*1882. Built in 1869-70 by John R. Cook, the building stood at the corner of Broadway Avenue and Second Street SW. In 1887 John Kahler became the hotel's manager directing an expansion and redecorating of the already plush establishment. Described as having "high-ceilinged rooms with white marble fireplaces and interminably long corridors," the Cook Hotel was a popular travel destination for decades.

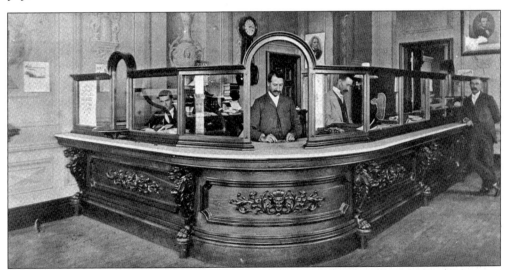

THE FIRST NATIONAL. Businessman, John R. Cook founded the First National Bank with four other investors and an operating capital of $50,000.00. The bank opened on December 1st, 1864, in a wood frame building on the corner of First Avenue and Third Street SW. In 1869 the offices were relocated to the northeast corner of the Cook Hotel's first floor (pictured) and remained there until 1949. From left to right are Simon Peeney, Walter Hurlbul, Charles N. Ainslee, and William W. Churchill.

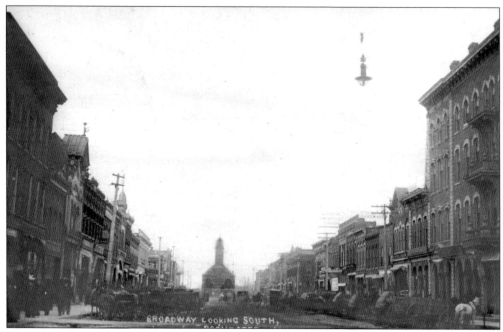

BROADWAY LOOKING SOUTH. An early view of Rochester's Broadway Avenue, looking south with the Cook Hotel at near right and the tower of the Rochester Fire Department's Central Station framed at the far end of Broadway. For many years Broadway Avenue ended at Fourth Street South due to the unbridged bend in the Zumbro River just south of there. For many years the stately central fire station occupied this prominent spot.

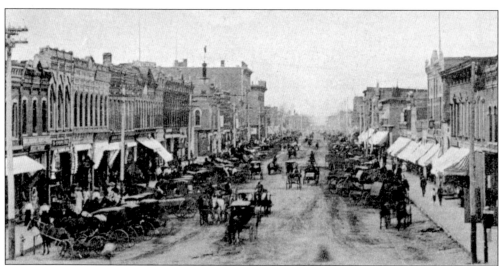

BROADWAY LOOKING NORTH. Utility poles rise up near storefronts as horse and buggy rigs crowd Broadway Avenue. With so many vehicles in use regulation was imperative. In 1867 a city ordinance was enacted that prohibited "the running, racing or immoderate driving or riding of horses or mules in the streets of the city of Rochester." Another ordinance forbade the hitching of horses or other domestic animals to telegraph, telephone or electric light poles.

DRY GOODS AND NEWSPRINT. McKay & Company Dry Goods shared accommodations with the Minnesota Record as shown in this photo, c. 1882. McKay's offered "an immense stock" of merchandise, from "dress goods, dolmans, shawls and black and fancy cloakings" to "ginghams, notions hosiery and yarns" at the "very lowest prices, for cash". Not to be outdone, a competitor, Cheap Charley, advertised, "Not Enough Money, that's what's the matter with Cheap Charley. Goods must be sold. Price no object!" J.D. Blake & Co. took a more dignified approach, assuring customers, "we are the oldest, largest, cheapest and most complete establishment in the city." An 1874 history of Rochester's various newspapers included

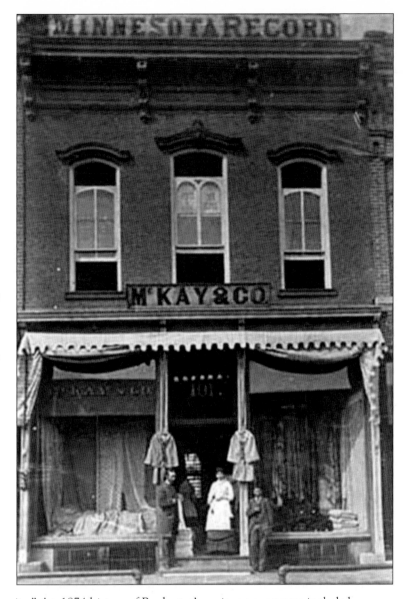

mention of the Minnesota Record. The publication reported, "The Olmsted County Journal, started in 1857, was the first newspaper published in Rochester. It was merged into the Rochester Free Press in 1858. In the fall of 1857 the Rochester Democrat was started, and about the same time the Weekly News. They were merged into the Rochester City Post, which was published in the fall of 1858, by Blakely & Brother. In November 1865, it became the property of Leonard & Booth, and under their management has become the leading paper in this section of the country. The Union made its appearance in 1866, and the Record in 1871. They were consolidated in 1874, and have a large and increasing circulation." The earliest Rochester newspapers were a far cry from today's expansive and sophisticated offerings. The Rochester City Post of the 1860s amounted to only a few scant pages and contained close-set type largely unadorned by photographs or even the pen and ink illustrations and cartoons that were extensively used by the 1890s.

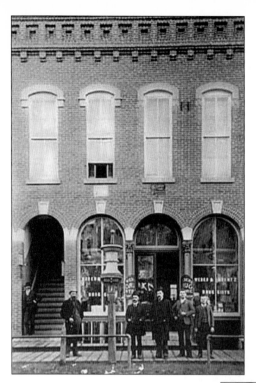

THE CURE. Weber & Heintz Drug Store is pictured *c.* 1880. Woodard's, another Rochester druggist of the day, confidently advertised "a certain and powerful remedy for weakness of the procreative organs. Prepared by an eminent physician of the city and known as the only remedy that will surely and permanently restore to a natural state of health and vigor persons weakened by excess or by the indiscretions of early youth." The wonder formula was available upon request for one dollar per vial.

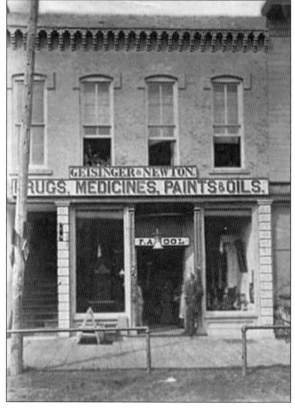

EARLY MAYO OFFICES. The second floor of this building housed William Worrall Mayo's medical practice at the time this photograph was taken in 1882. The good doctor advertised office hours of 1pm to 5pm, presumably because he was kept busy visiting patients during the morning hours. The business of Geisinger & Newton Drugs, Medicines, Paints & Oils occupied the first floor. The patrons of both businesses likely benefited from this convenient arrangement of services.

Two
CATALYST OF CHANGE

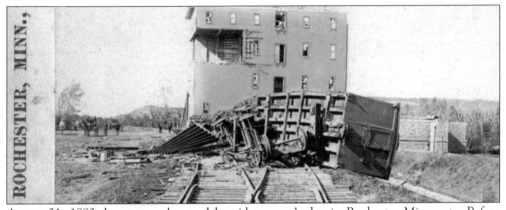

August 21, 1883, began as a hot and humid summer's day in Rochester Minnesota. Before nightfall the whim of nature turned dark and a cataclysmic storm descended on the young community. The *Rochester Post* described the tornado, which came out of the west, as being "like a great coiling serpent, darting out a thousand tongues of lightning, with a hiss like the seething, roaring Niagara." Furious winds slammed into homes and buildings, pealing away roofs like paper and flattening walls of wood and brick. Unprepared for the violence of the tornado, the citizens of Rochester lost at least 26 killed, with more than one hundred injured. The entire assault lasted only a matter of minutes but left behind a broad field of devastation and woe. Local physicians, including Dr. William Worrall Mayo, came to the aid of the injured. Victims were attended in makeshift hospital quarters in Rommel's Dance Hall, the German Library Association's lodge and the Convent of the Sisters of Saint Francis. Under the direction of Mother Mary Alfred Moes the Sisters of Saint Francis provided supervision for the many volunteer nurses, and in the weeks that followed Mother Alfred became convinced that Rochester needed a permanent hospital. She approached Dr. W.W. Mayo with an offer that the Sisters of Saint Francis would provide for a facility if Doctor Mayo would see to its staffing. Although initially reluctant, Doctor Mayo ultimately adopted the venture with characteristic energy helping with plans for what was to be a thoroughly modern 27-bed hospital. The neat, new red brick building was named Saint Marys Hospital and opened on September 30, 1889.

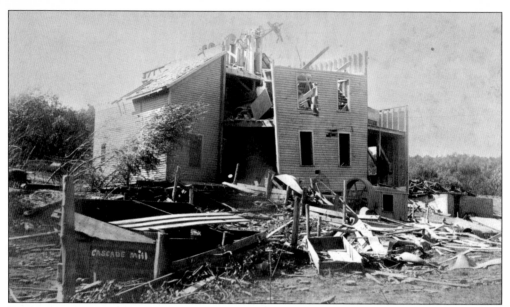

REMAINS OF CASCADE MILL. Reports of the day paint at least a partial image of the scene in the skies around Rochester on August 21, 1883. The air was thick with humidity and the sky a dull leaden color. A brief thundershower failed to clear the oppressive atmosphere and townsfolk watched warily as dark clouds took on a coppery, greenish hue. Some prudent residents responded to the sight by retreating to their cellars.

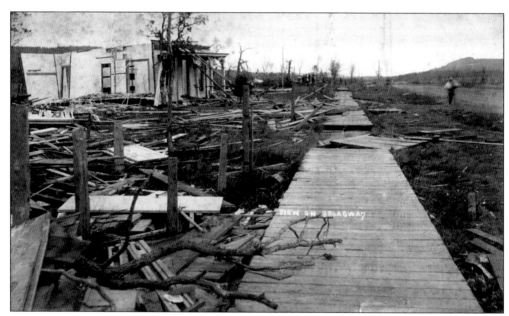

"SAD HISTORY OF DISMAY, DESTRUCTION AND DEATH." Such was the headline in the *Rochester Post* following the August 21st tornado. "Barns and houses in the streets are utterly destroyed," reported the newspaper, "But worse than all the rest was the news that flew from lip to lip that in North Rochester many lives were lost and many were wounded." The lonely remains of a home sit amid scattered debris and shredded trees in this view of north Broadway.

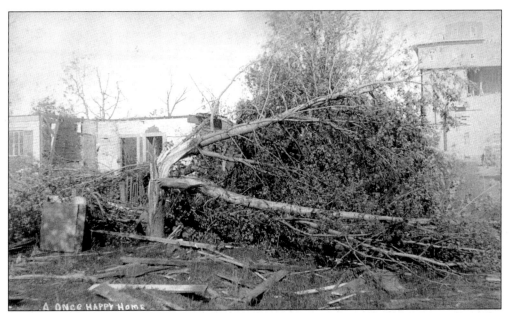

AFTERMATH. Newspapers lamented in the aftermath of the storm describing streets as "literally blocked with debris of every kind of trees, house roofs, lumber" and great rolls of tin from the roofs of businesses. "Buildings were absolutely swept out of existence. Trees were torn out and stripped of their leaves, timbers driven into the ground as though fired from a cannon. The earth is strewn with [dead] horses, cattle and debris," reported the *Post*.

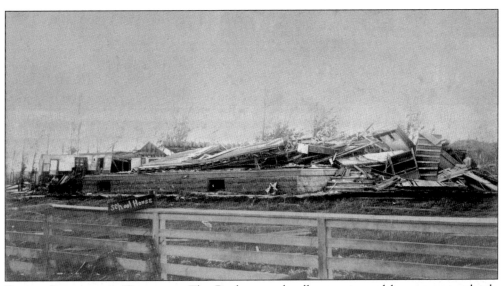

PUBLIC STRUCTURES DAMAGED. The Rochester schoolhouse pictured here was completely flattened by the tornado while the Central High School building suffered the loss of its roof and one tower. The courthouse was partially unroofed and its dome destroyed. Several churches suffered the loss of steeples including the Congregational Church, the Methodist Episcopal Church and the German Lutheran Church. The Chicago & North Western's roundhouse was destroyed, the depot unroofed and the railroad bridge blown into the river.

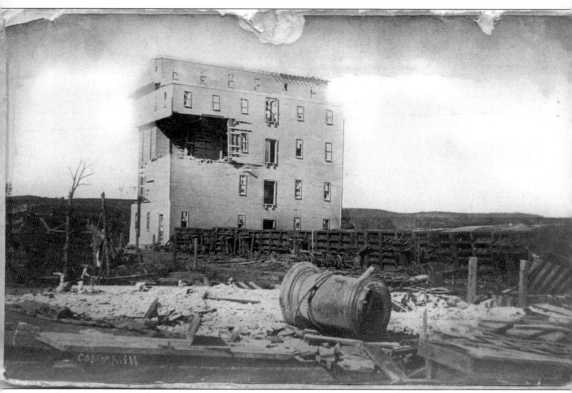

CAUGHT IN THE OPEN. Cole's Mill is shown here, heavily damaged by the cyclone. The stove in the foreground of the photograph came from the leveled home of a mill employee, Paul Thompson. Between the stove and the mill is a row of heavy railroad freight cars flipped carelessly off the tracks by the massive power of the wind. Many of those who died were caught by the storm while away from shelter. John M. Cole, owner of Cole's Mill and director of the Union National Bank, was killed while traveling from the mill toward the safety of his home. The Cole Mill was the second mill constructed in Rochester and one of several that served the prosperous farming community. Frederick T. Olds established Rochester's first mill on Third Street SW in 1856. The mill adjoined the Zumbro River and cost $40,000 to construct. Billed as "in excellent running order" and handling "custom grinding," F.T. Olds encouraged farmers to "remember the big stone mill near the city bridge is the place to get grinding done with dispatch." In 1874 it was reported that, "Rochester has become one of the great points in the world for the primary shipment of wheat, more than 1,000,000 bushels being here received in the year 1873. The manufacture of flour is extensively carried on here, and there are four large mills running, three by waterpower and one steam-mill. The flour is of the finest quality; twenty thousand barrels were shipped from here in 1873; the shipment will nearly reach 50,000 barrels the present year. A large iron foundry, carriage factory and woolen mill, are doing a heavy business." The carriage factory was among the businesses destroyed by the cyclone, as was the Rochester Harvester Works.

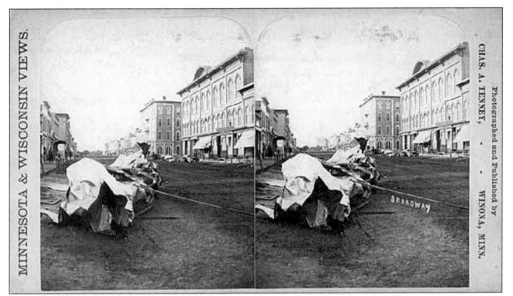

A NEAR MISS ON BROADWAY. A jagged section of roof cornice nearly ended the lives and careers of two young Rochester men destined to be prominent citizens and physicians of world renown. Torn from its place by the fury of the cyclone, the cornice of the Cook Hotel crashed into the street smashing the dashboard of a buggy driven by Will and Charlie Mayo. Their mare bolted away and the two brothers took refuge in a nearby blacksmith's shop. Both escaped serious injury.

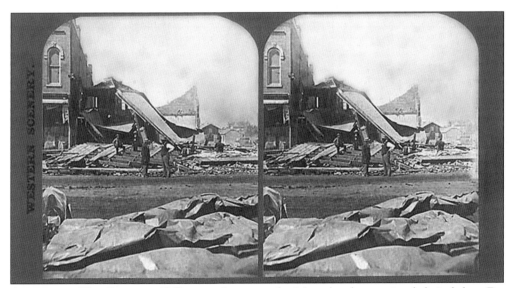

ATTENDING THE INJURED. Following the storm the Mayo brothers assisted their father, Dr. W.W. Mayo, in attending to the many injured. Dr. Will had recently graduated from the University of Michigan Medical School. Charlie Mayo was just 18 at the time but had already been assisting in his father's surgical practice for 10 years. Dr. Will once said of he and his brother, "We came along in medicine like farm boys do on a farm."

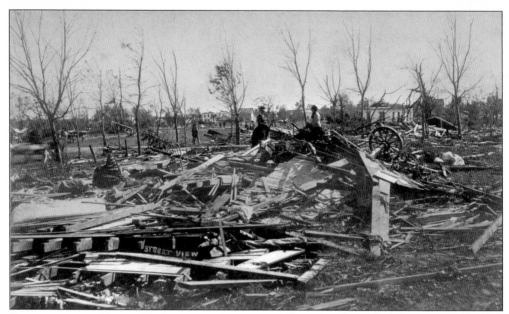

SEARCHING THE RUINS. Rochester residents were left to sort through the remains of homes, barns, public buildings and businesses following the devastating cyclone. One resident discovered their mantel clock, unharmed but missing its weights, under a neighbor's building, which had been lifted from its foundation and deposited several yards away. The weights were later discovered in yet another location. The *Rochester Post* listed numerous homes as damaged or "badly racked" while a great many others were "utterly annihilated."

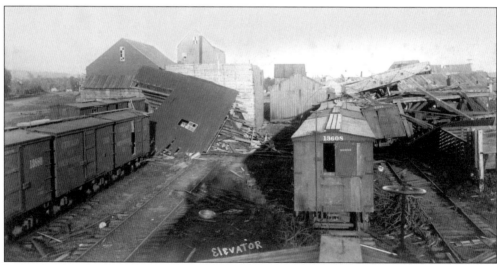

RELIEF WORK. As word of the devastation in North Rochester spread citizens rushed to the aid of their neighbors. The Post reported, "The hotels in the vicinity of the railroad were used as hospitals and into these the wounded were carried." "All night long the work went on. In the morning the families who could do so furnished food to the homeless, and the bakeries were drawn upon to supply their meals."

DR. W.W. MAYO. Doctor William Worrall Mayo's varied life experiences included working as a ferryman, a census taker and a steamboat officer, a newspaper publisher and a pharmacist. He also served as a justice of the peace and as Rochester's Mayor (1882–83). He was an examining physician for the Union Army, and a country doctor. His most far reaching and best remembered role was as originator of the medical practice that evolved into one of America's greatest medical entities: the Mayo Clinic.

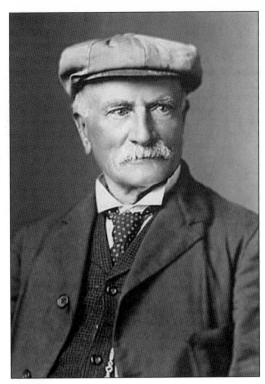

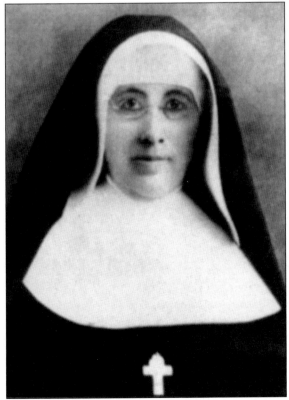

MOTHER MARY ALFRED MOES. Born in Luxembourg, Maria Catherine Josephine Moes traveled to America in 1851 and took the name Sister Alfred upon becoming a nun. She established an order of Franciscan Sisters in Illinois, becoming Mother Superior of the order. Arriving in Minnesota in 1876, she started a school in Owatonna before establishing both a school and motherhouse in Rochester. The primary advocate for the creation of Saint Marys Hospital, Mother Mary Alfred retired to St. Paul in 1890 where she died in 1899.

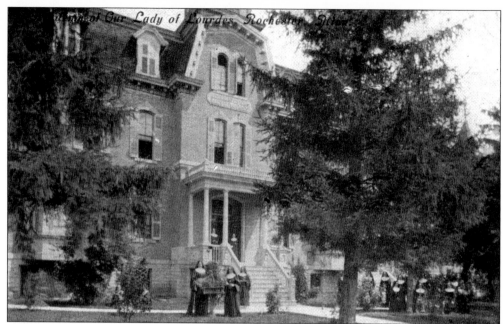

THE ACADEMY OF OUR LADY OF LOURDES. Mother Mary Alfred came to Rochester on May 24, 1877, to confer with Father Thomas O'Gorman, Pastor of St. John's Church, about the establishment of a school for young women. Shortly thereafter a site was purchased on West Center Street and work begun. On December 3, 1877, classes were opened with 210 pupils admitted to the Academy. The new structure served as Motherhouse, Novitiate, Boarding and Day School.

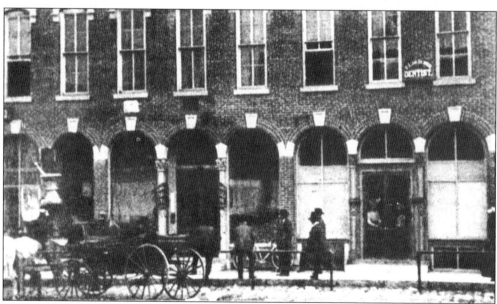

OFFICES OF THE DOCTORS MAYO. William Worrall Mayo moved the offices of his medical practice into the Cook Block in 1883, the same year as the horrific tornado of August 21st. This photograph dates from that same fateful year and shows a carriage that is likely one of those used by the Doctors when calling on patients. The Mayo offices remained at this location at First Avenue and Second Street SW from 1883 to 1901.

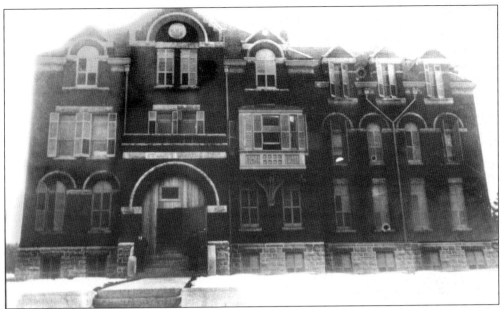

ORIGINAL SAINT MARYS HOSPITAL. Mother Alfred promised Dr. Mayo that she and her order would raise the money to build a hospital. By 1888 the Sisters had saved $40,000 for that purpose. Dr. W.W. Mayo purchased 40 acres of land from John D. Ostrum and presented it to the Sisters. The contract for construction of the new facility was let on August 1, 1888, and the hospital opened on September 30, 1889.

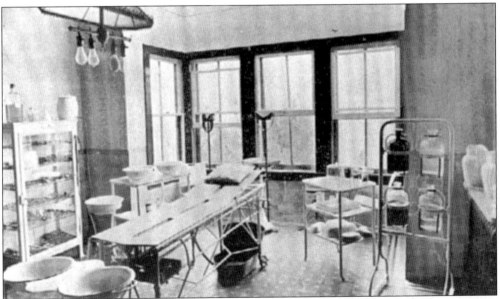

A THOROUGHLY MODERN HOSPITAL. Dr. W.W. Mayo's initial reluctance toward the hospital venture was due in part to the then prevalent notion that hospitals were places where people went to die. After some reflection Dr. Mayo agreed to the proposal and with his eldest son, Dr. William J. Mayo, traveled abroad to study the best hospitals in Europe. Pictured is the hospital's first operating room c. 1893. The room included three windows and a skylight. Two gaslight fixtures provided illumination after dark.

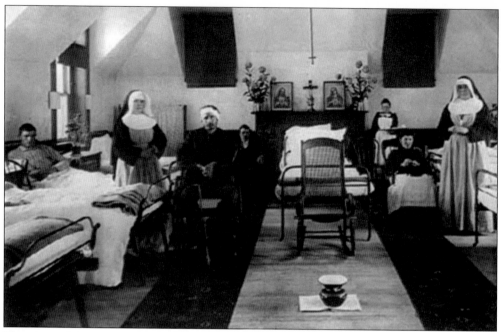

HOSPITAL ACCOMMODATIONS. This ward in Saint Marys Hospital seems to have all the amenities; beds, rocking chairs, plenty of sunlight, religious icons, flowers, fireplace and in the room's very center... a spittoon? The two women in nun's habits are from the order of the Sisters of Saint Francis. These original nurses cared for the ill and injured as well as attending to the many other daily chores needed to keep the hospital in order.

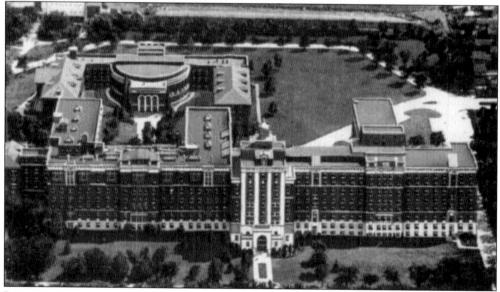

LEGACY OF A DISASTER. Pictured is Saint Marys Hospital about 1950. Other disasters have befallen Rochester during its history, but none bears such a strange and enduring legacy as the tornado of 1883. Saint Marys Hospital and the expansive medical center that grew up around it and the Mayo medical practice commemorate the savage destruction, injury and loss of life, endured by Rochester's citizens in that distant dreadful August.

Three

COMMUNITY
1883–1929

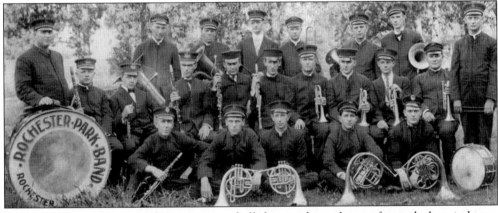

During its history Rochester has experienced all the wonder and woe of growth, loss, industry, challenge, recession, expansion, depression, renewal and perseverance that marks the path of most communities. There have been established here fine schools, sound businesses, and beautiful houses of worship. Industry in the town has included the milling of wheat, rye and other grains, as well as the manufacture of furniture, coffins, corsets, candy, cigars, soaps, cameras, bedsprings, shoe polish, paint, boots, plows, patent medicines, and more. The town has been both wet and dry in respect to alcohol consumption and has seen the revolving wheel of business open and close the doors of hundreds of shops offering thousands of products, from oysters and liver pills to gingham dresses, corn shellers and hay rakes. Immigrants from dozens of countries have integrated into this community the strengths of their cultures making Rochester all the richer. Innovation, hard work and an enduring desire to ensure the continued growth and prosperity of this city have succeeded in doing just that. Generations of citizens have committed their energy to the day-to-day business of building and maintaining what one local editor praised as "a community more blessed and worthy of praise than perhaps any other" in the country.

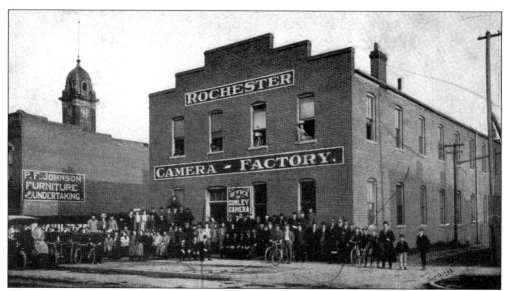

STILL STANDING. This group, gathered in front of Conley's Rochester Camera Factory near the turn of the century, is likely made up of the factory's management and employees. The building at left bearing the sign for P.F. Johnson Furniture and Undertaking is in fact the building that housed that business. Altered but still recognizable, both of these buildings remain standing on Fourth Street SW just west of Broadway Avenue.

ODD COMBINATION. Today it may seem a strange combination, but many undertakers of the 1800s and early 1900s also sold furniture, or rather many furniture dealers were also undertakers. Whichever the case, the practice was commonplace. Shown is P.F. Johnson Furniture and Undertaking on the southwest corner of Broadway Avenue and Fourth Street SW in 1879.

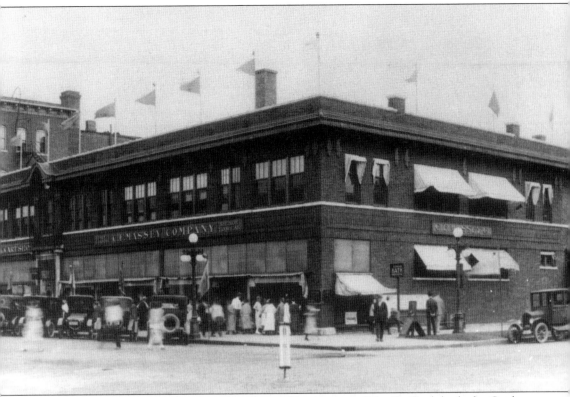

THE BLOCK THAT COOK BUILT. Local banker and businessman John R. Cook built the Cook Block in 1878. Mr. Cook was also responsible for the construction of the Cook Hotel in 1869–70 and the establishment of Rochester's first bank, the First National Bank of Rochester, in 1864. For many years the Cook Block was occupied by the C.F. Massey Company, a prominent Rochester business founded in 1875. Samuel C. Furlow joined C.F. Massey in the company's second year and later became a partner. The business offered a wide array of apparel and other dry goods. "The best evidence that we are selling goods at right prices and according to the times," claimed C.F. Massey in 1880, "is to come in and see the crowds who are eagerly purchasing." The offices of the Doctors Mayo were established in this building from 1883 to 1901. In 1891 Dr. Charles H. Mayo installed a phone line connecting these offices to Saint Marys Hospital.

The Cook Block underwent remodeling in 1911 and has remained largely unaltered in appearance from that time. This historic building still stands on the southeast corner of First Avenue and Second Street SW.

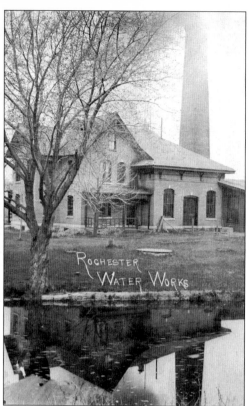

ROCHESTER WATER WORKS. Rochester's first water service was established in 1887. That same year the Saint Mary's Park standpipe was constructed. This remained the city's only water storage facility until 1916. Rochester's first water works plant, pictured, was located on Fourth Street SE. Keeping pace with Rochester's rapid growth was challenging for the utility, as frequent extensions of water main were required to meet burgeoning demand. In 1916 the city purchased a private water company and created Rochester's first water department.

CITY BUILDINGS. From left to right are the City Hall, Rochester's first Electric Light Plant, and the Fire Department Headquarters. The City Hall was built in 1884 on the corner of First Avenue and Third Street SW during the period that Dr. W.W. Mayo was Mayor of Rochester. The structure housed both the police station and a lock-up area. At the time of its construction the building was called, "one of the most imposing buildings in the state."

40

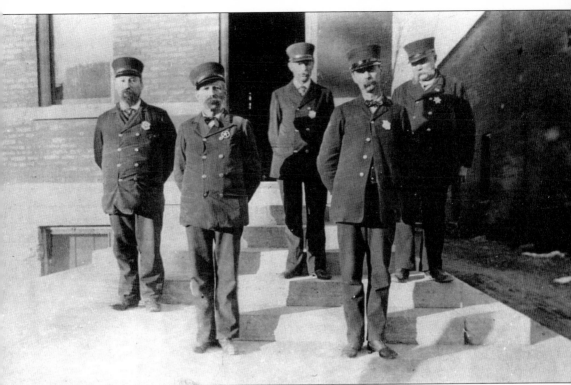

ROCHESTER POLICE FORCE, 1890S. Henry Kalb, second from left, was elected city marshal in 1877 and remained in that post until 1899. A German immigrant, Kalb settled in Rochester in 1856. Joseph A. Leonards noted the marshal's character in a *History of Olmsted County, 1910,* "Marshal Kalb, though quietly unassuming, was strict in the enforcement of the law, and with the tramps and toughs, who were numerous in those days, his word was law. They held him in the same reverence as did a couple of College Street youngsters of that mischievous age [who] had earned a neighborhood reputation for youthful naughtiness. Bob was heard to say to his comrade after a suggestion of some prank, 'We could have a good time, couldn't we, Willie, if it wasn't for Marshal Kalb and God.'" On June 15, 1879, Marshall Kalb's character was tested when the village marshal from Kasson requested assistance in apprehending Dan Ganey, a notorious burglar. Ganey had escaped arrest in Kasson and fled to Rochester. Marshal Kalb located and arrested Ganey. However, near the corner of Fifth Street (now West Center Street) and Broadway, while being escorted by Kalb to the Kasson marshal, Ganey suddenly drew a revolver and threatened Kalb. When the marshal declined to be intimidated, the desperate burglar fired at him! The shot missed and Marshal Kalb returned fire. Each man fired two shots, Kalb's second shot fatally wounding Ganey in the chest. Pictured from left to right are John Thomas, Marshal Henry Kalb, Louis Ranfranz, George McDermott and George Radabaugh.

41

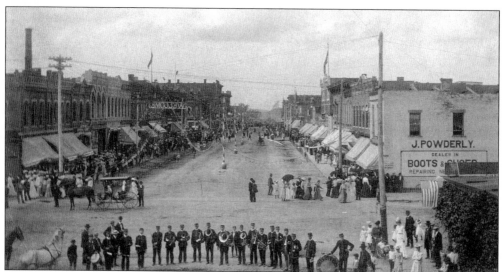

PULSE QUICKENING PREPARATION. Here is a view of South Broadway looking north in 1904. Rochester's Queen City Band is visible in the foreground as they prepare to perform for what is likely a Fourth of July celebration. The *Rochester Post* characterized the nature of such celebrations in 1883 with the question, "What person is there in this favored land whose pulses do not quicken at the sound of preparation for the observance of the anniversary of America's independence?"

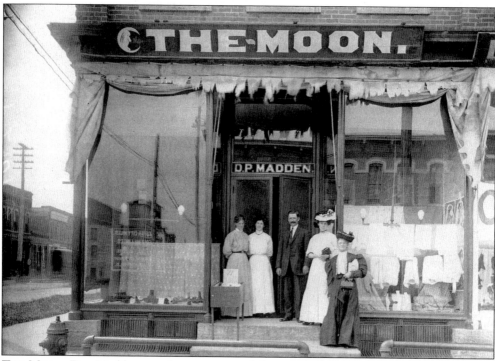

THE MOON. Dan Madden was the proprietor of this unusually named dry goods store located on the corner of Third Street SW at 229 South Broadway. Mr. Madden is likely the gentleman seen bracketed by ladies in this photo from 1904. The building was later razed to make room for a parking lot. The Hilton Hotel was constructed on the site in 1999.

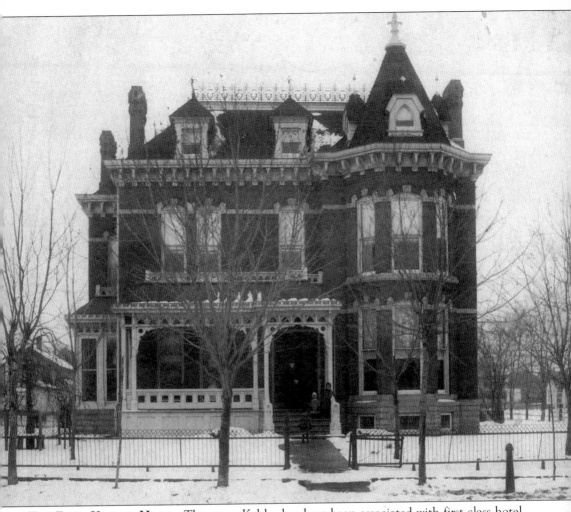

THE FIRST KAHLER HOTEL. The name Kahler has long been associated with first class hotel accommodations in Rochester. John H. Kahler, the son of a German saddle maker, came to Rochester in 1887 to take over management of the majestic Cook Hotel. Despite being considered the finest hostelry in southern Minnesota, the Cook Hotel had suffered from sparse patronage and was not a financial success until John Kahler became manager. The first hotel to bear the name Kahler is pictured here, c. 1907. Built as a spacious private residence by and for businessman J.D. Blake in 1875, this house was sold to Albert Narrington in 1885 and then to E.A. Knowlton, another prominent Rochester business leader, in 1889. The Rochester Sanitarium Company, with John Kahler as general manager, purchased the home in July of 1906 and converted it for commercial use. It was sold to the Kahler Hotel Co. on March 1, 1913, and was operated as the Kahler Hotel. When the new Kahler Grand Hotel was completed in 1921 this "original" was renamed the Damon and continued as a hotel until demolished in December of 1960 to make room for a parking lot and later the Damon Parkade Parking Ramp. The name Damon was reportedly chosen to honor Hattie Damon Mayo's family. Hattie was married to Dr. William J. Mayo.

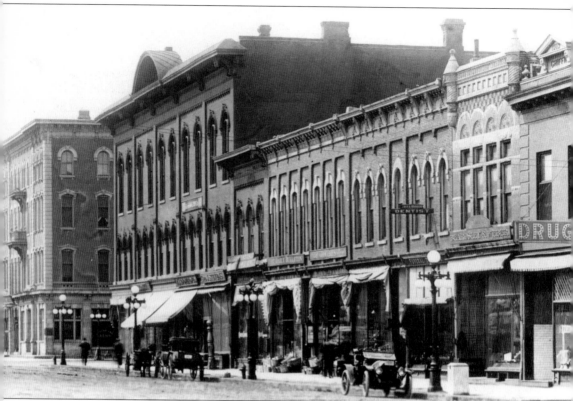

BROADWAY LOOKING SOUTH, 1909. The four-story Cook Hotel is at left in this photo from 1909, while to its right, just across Zumbro Street (now Second Street SW) is the three-story Heaney Block built in 1867. The Grand Opera occupied the third floor of the Heaney Block with the E.A. Knowlton & Co. store and the J.B. Wright's Barber Shop below. Following the Heaney Block on the west side of South Broadway were, from left to right, the George Stevens Carpet Store at 115, Grim Brothers Meats at 113, the W.F. Klee Grocery at 111, the J.A. Pierce Grocery at 109, the A.D. Twiss Grocery at 107, T.R. Lawler Furniture and Undertaking at 105 with Dr. F.D. Booker–Dentist in offices above, Beardsley & Weber Harness & Leather Store at 103, and Paul Hargesheimer Drug Store at 101 on the corner of First Street and Broadway Avenue. Today it would seem strange to have three grocery stores along the same stretch of street, but these three establishments managed well and were reportedly on very good terms with each other.

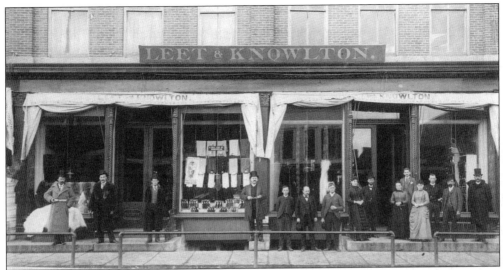

LEET AND KNOWLTON. In 1861 John D. Blake started a dry goods business in Rochester. Alfred D. Leet joined Blake in 1865 and Elliott A. Knowlton in 1867. The three men built a robust business that became known as Leet and Knowlton in 1882 and later E.A. Knowlton & Co. Here the Leet and Knowlton staff poses outside the store, located in the Heaney Block, in about 1900.

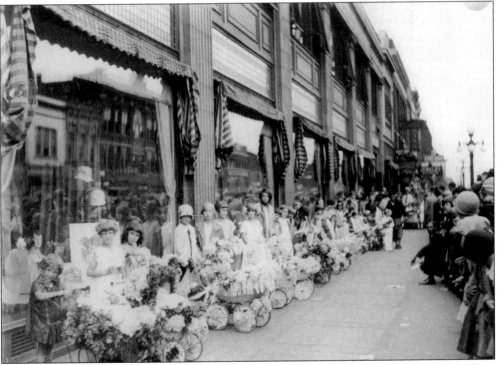

NEW LOCATION. Children are assembled for the Rochester Peony Parade on June 22, 1927, in front of E.A. Knowlton & Company's "new" department store. After his business in the Heaney Block was destroyed by fire on January 17, 1917, E.A. Knowlton purchased the property at the corner of Broadway and Second Street SW and in 1918 built a new two-story building. This building was later purchased by Dayton's and razed to make way for a new Dayton's store.

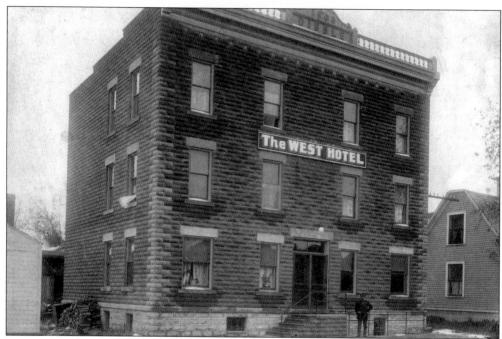

PROUD OWNER. M.L. Dibble is shown standing in front of the West Hotel, which he built at 110-112 West Fourth Street (now First Street SW) in 1905. The building and property were later purchased by the Kahler Corporation along with land west of the West Hotel for construction of the Zumbro Hotel. The Kahler's expansive Zumbro Hotel was completed in 1912.

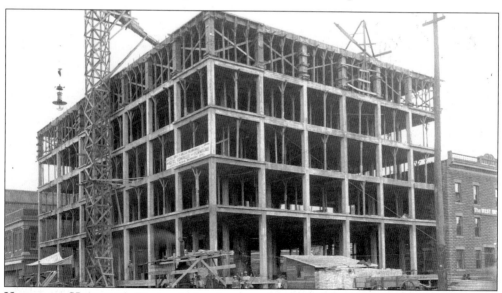

HOTEL OR HOSPITAL? Distinguishing between hotels and hospitals could be difficult in Rochester's early years. The Zumbro Hotel, shown while under construction, opened for business in 1912 with 48 "patient guest rooms" and an operating room! The building was located on the corner of First Avenue and First Street SW with the West Hotel adjacent. An eight-story annex was constructed in 1917 with space for medical offices and laboratories, which were occupied by Mayo Clinic staff.

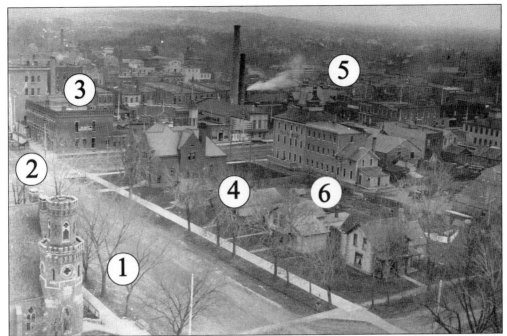

VIEW FROM THE SCHOOL. This photo was likely taken from the tower of the Central High School looking southeast in about 1907. **1)** The Unversalist Church, later site of the Mayo Clinic's Plummer Building. **2)** The intersection of Second Street and First Avenue. **3)** C.F. Massey's in the Cook Block. **4)** Rochester's "Red Brick" Public Library. **5)** The Rochester City Hall, partially closed. **6)** The Rochester Hotel. Rochester's population at this time was approximately 7,230.

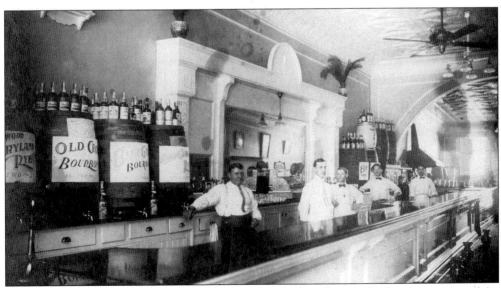

BEER AND BILLIARDS. The saloon business was largely about beer and billiards for many of the establishments that came and went during the nineteenth and early twentieth centuries. The White Front Saloon was located at 110 South Broadway and is shown here in about 1910. The White Front was clearly a dapper joint, with its white bar, tin ceilings and abundant spittoons. From left to right are Charles Grassle, George McDermott, and three unidentified staff.

47

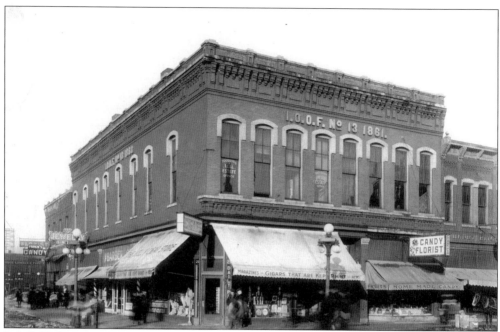

I.O.O.F. No. 13. The International Order of Odd Fellows raised this building on the northeast corner of Second Street and First Avenue SW in1861. The building was home to the Rochester Post Office until 1912 when it moved to a new building one block North. Rochester's first post office was housed in a log cabin built by Robert McReady, with letters carried by stage at a cost of three cents each.

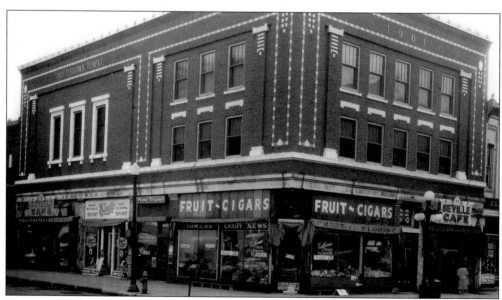

TRANSFORMED. This is the same building as pictured above. An addition was added in 1910 and the entire structure renovated with brick veneer and decorative work in 1934. The second floor accommodated the lodge rooms while the post office leased the first floor for a reported $225 a month. Note the Seville Café, later the Green Parrot Café, on the first floor. The Brackenridge Building can just be seen at right.

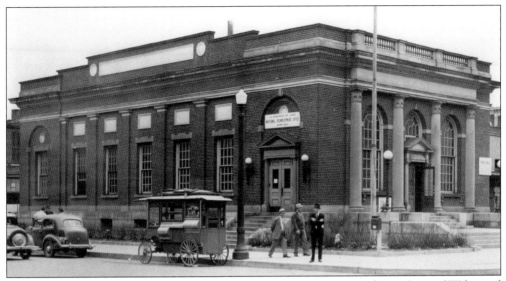

POST OFFICE BUILDING. This impressive building at First Avenue and First Street SW housed the Rochester Post Office from 1912 until 1934. The building was torn down in 1938 to make room for the 100 First Avenue Building. The Rochester Post Office gained First Class status on July 1, 1914. In that same year carriers earned thirty cents an hour and bicycles were used to deliver the mail on some routes.

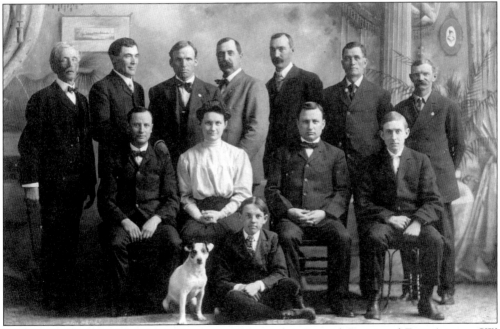

POSTAL EMPLOYEES. The post office was still housed at Second Street and First Avenue SW when this photo of Rochester postal employees was taken in about 1909. Pictured from left to right are: (front row) James Matheson, Miss Mary Sweeney, Leon Williams, and Howard Mulholland; (back row) James Jacks, Reed Haggerty, Tal Williams, Frank Lyons, Henry Wrought, Art Graham, and William Rowley. Seated next to the unidentified dog is Harry J. Rowley, who ran errands.

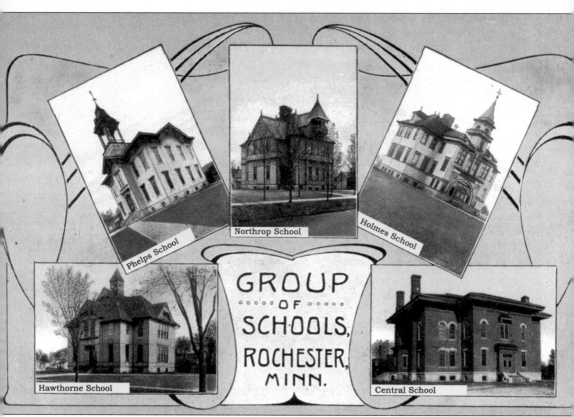

Phelps School

Northrop School

Holmes School

GROUP ○○○○○ OF ○○○○○ SCHOOLS, ROCHESTER, MINN.

Hawthorne School

Central School

EARLY SCHOOLS. A number of schools were constructed in Rochester between 1868 and 1898. The Central H.S. was opened in 1868 (shown here with just two stories following the 1910 fire), Phelps and Northrop Grade Schools were built in 1875–76 and Our Lady of Lourdes Academy (not pictured), a girl's school for day students and boarders, was opened in 1877. The Rochester Record and Union described the academy as being "furnished in excellent taste. On the second floor are classrooms, and also a recreation room for use when the weather is inclement. The top floor is devoted mainly to dormitories for the Sisters, postulants, and students. Each of the comfortable looking beds is for only one person. The bathrooms are equipped with hot, cold, and shower baths." In 1882 St. John's Grade School (also not pictured) was opened on the southeast corner of First Street and Sixth Avenue Northwest. Holmes Grade School was built in 1896. The Hawthorne School pictured here burned in 1913 and was replaced with a larger brick structure of the same name at the same location in southeast Rochester.

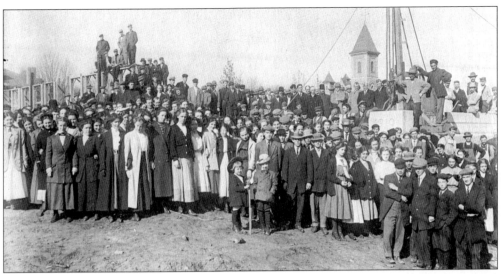

LAYING THE CORNERSTONE. A considerable throng gathered for the laying of the cornerstone for the new Coffman High School in 1910. Building a new high school became imperative after a fire on September 1, 1910, destroyed the upper floors of Rochester's Central High School. Coffman H.S. served as the city's only public high school until the fall of 1958 when John Marshal H.S. opened to students. Mayo High School graduated its first class in 1967 and Century High School admitted students for the first time in 2001.

SCHOOL BOOM. Rochester experienced rapid growth from 1910 to 1920 as the city's population jumped from 7,844 to 13,722 inhabitants. School construction increased to keep pace. Coffman High School, pictured here, was completed in 1911. St. John's Parochial School and Heffron High School for boys were built in 1912 and in 1913 the tiny Trinity Lutheran School expanded into a new two-story brick building. Heffron H.S. became the co-educational St. John's H.S. in 1926 and Lourdes H.S. in 1942.

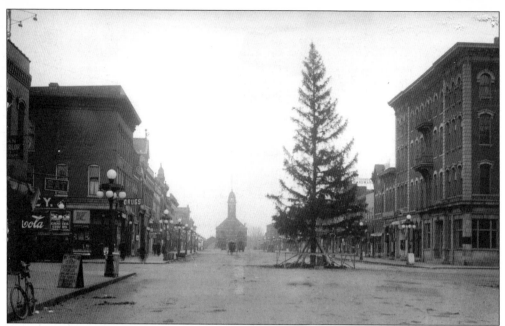

COMMUNITY CHRISTMAS TREE. The intersection of Broadway Avenue and Second Street was host to this holiday addition, a towering fir tree, in about 1900. It is unclear how long this tradition lasted in Rochester, but one could surmise that it would not be popular with modern motorists. Charles Gray began selling Christmas Trees in Rochester in about 1892. The trees were brought in from Wisconsin and sold from a rented storefront.

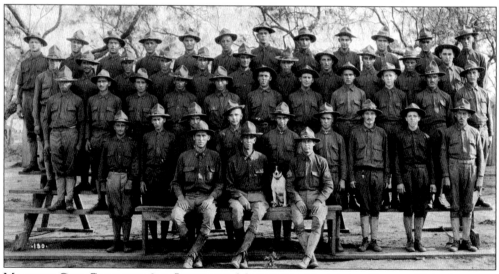

MACHINE GUN COMPANY, 3RD INFANTRY, MINNESOTA NATIONAL GUARD. This photo was taken in July of 1916 at Fort Snelling prior to the unit's departure for service on the Mexican Border against Pancho Villa. Among the Rochester men in this company were Captain Fred C. Ormond, Albert Schuchman, Walter Matzke, Emil O. Leudtke, Fred Witzke, Harry A. Purves, Sgt. James Mc Crudden, Carl Moe, Carl Nelson, Albert Lind, John Daly, Claude Brehmer, Dale Burnham, John Farley, Albert Spring, Leslie Williams, Lewin N. Sheffer, Horace Jeffery, John Holland, Albert Saskowski, Albert Gillies, John Miller, Theodore Fluegel, and George Dobson.

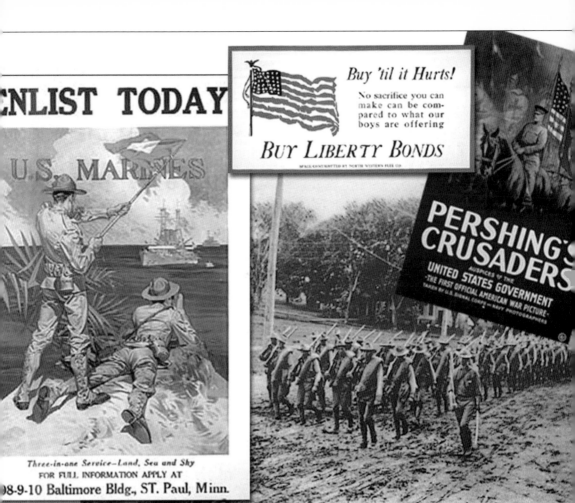

THE MARCH TO WAR. In 1917 Minnesotans responded to the call to arms in characteristic fashion. The first state to contribute volunteers for the Union in 1861, Minnesota was also first to respond in April of 1898 when the Spanish American War broke out. Following America's entry into WWI, Minnesota contributed nearly 120,000 soldiers. A thousand nurses also joined the service during the war, many of them from Rochester. The first Rochester native killed in the conflict was Morley Wilkins. In all, 3,480 Minnesotans gave their lives to the struggle. Even though they were not recognized as U.S. citizens, many Minnesota Dakota and Ojibwa volunteered to fight for the United States. At home, citizens were encouraged to contribute through the purchase of Liberty Bonds. "Buy 'til it hurts" was the slogan, "No sacrifice you can make can be compared to what our boys are offering." Anti-German hysteria swept through the country. A 1918 article in the *Rochester Daily Bulletin* announced, "to safeguard the property of the Rochester Milling Company against incendiary fires of a pro-German origin, an armed watchman now patrols the premises during the night."

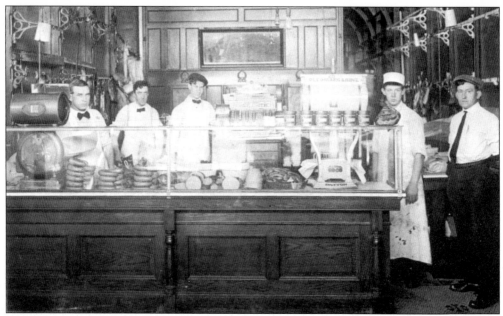

BAIHLY'S MARKET. Founded in 1858 by George Baihly and continued in 1893 by his son, Ralph Baihly, Baihly's Market served Rochester consumers for 95 years. The business, which closed its doors in 1953, was located for many years at 108 South Broadway and carried on stock buying and shipping as well as the operation of slaughter facilities. Pictured from left to right are William Reick, Edward Grimm, Max Brumm, Ernest Hill, and Charles Palmerlee.

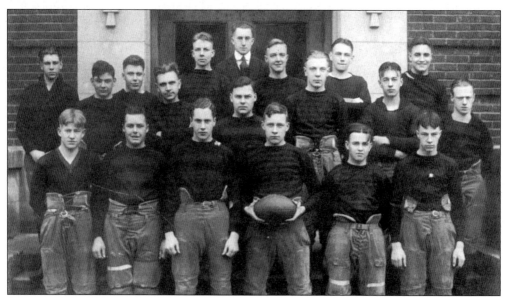

ROCHESTER H.S. FOOTBALL, c. 1920. Heffron High School also fielded a team in the '20s, and in 1926 a short-lived pro football team called the Aces was established in Rochester. From left to right are: (front row) Glenn Amundson, Clarence Stewart, Kenneth Abernathy, Elmer Weinhold, Henry Maass, Floyd Hill, and Henry Kalb; (back row) Glen Fordham, Gordon Graham, Malcom Chapman, Emil Ludke, Oscar Studenroth, Roland C. Friderichs (coach), Clifford Alexander, Harold Hays, Walter Thompson, Max Kjerner, Fay Alexander, and Donald Taylor.

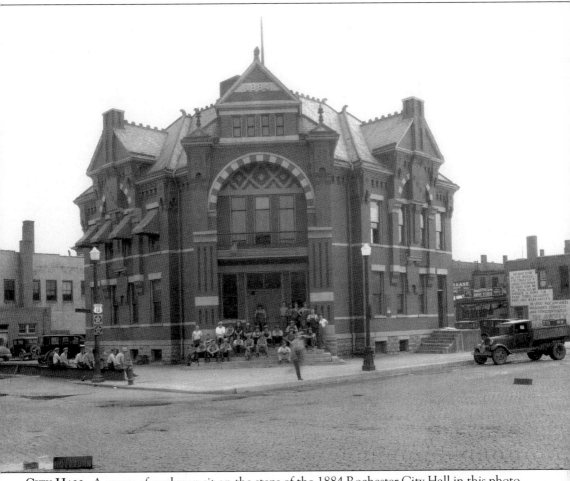

CITY HALL. A group of workmen sit on the steps of the 1884 Rochester City Hall in this photo from about 1920. Rochester's first city hall was in a one-story jailhouse built in 1866. The structure contained three cells and an office for the marshal that was made available for city council meetings. Behind the modest structure was a corral where stray pigs, cattle and horses were impounded. City ordinances made it clear in 1858 that "it shall be the duty of the Marshal, street Commissioners and Constables of the city to take up all swine that may be found running at large within the city limits." Their owners could redeem errant domestic animals for a fee of fifty cents each. When Rochester's first firehouse was built in 1870 the city council conducted meetings in a small hall on the second floor. "In the spring of 1882, Dr. W.W. Mayo was elected mayor and he was so exasperated that the council would hold its meetings in such a small, unsatisfactory place that at one time he left the chamber in disgust with the explanation that he would not return until some other location was secured," wrote Judge Burt W. Eaton in 1932, "Later, he did return, and his influence started the movement for the construction of a new city hall which was built in 1884." The "new" city hall, pictured here, cost $25,000 to build. It was razed in July of 1931 to make way for a "newer" city hall constructed at the same location on the northeast corner of First Avenue and Third Street SW.

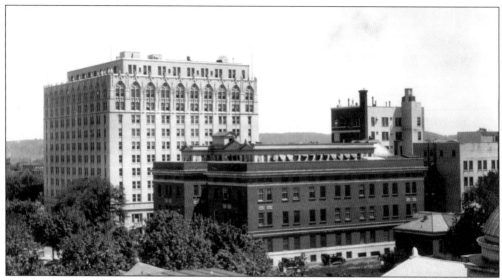

KAHLER GRAND. This Rochester skyline picture was taken after the construction of the 11-story Kahler Grand Hotel in 1921 (seen at left center) and before the construction of the Plummer Building in 1928. The brick structure at right center is the Mayo Clinic's 1914 Building. Known for its sumptuous style, the Kahler Grand was long the premier hotel in a city of hotels. Several heads of state have numbered among the hotel's many guests.

MULTIPURPOSE ACCOMMODATION. Like the Zumbro Hotel, the Kahler Grand was built with a medical angle in mind. The lower floors accommodated 220 hotel beds, the middle floors held a 150-bed convalescent home and the upper floors a hospital with 210 beds, a number of laboratories and three operating rooms. The hotel's hospital facilities were gradually eliminated between 1945 and 1955 and the hotel underwent an extensive expansion in 1952.

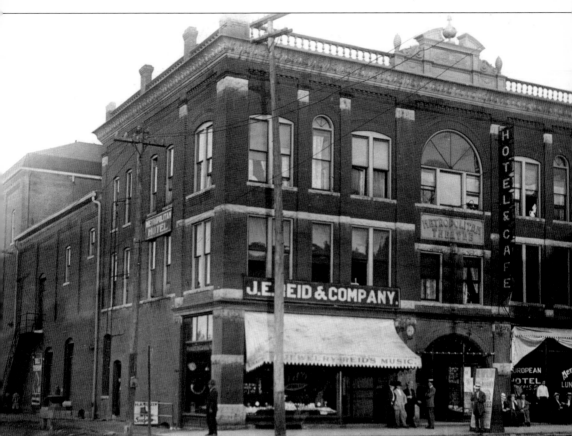

THEATRICAL MONUMENT. The Metropolitan Theatre, built in 1901 by J.E. Reid, was hailed at the time as "one of the prettiest, most complete and tasty theaters in the northwest." The venue drew top performers from all over the nation including headliners such as Walker Whiteside, The Cherry Sisters and Grace Hayward. Nationally known boxers and wrestlers also competed on the theatre's 33 by 65 foot stage. Eight hundred seats were available to the public, as well as eight private boxes. Productions included such varied fare as *Romeo and Juliet*, the musical *Naughty Marietta* and an unlikely professional drama entitled *Ole, the Swede Detective*. Local productions presented by various organizations and schools also graced the Metropolitan's stage. The Rochester Junior College (founded in 1915) staged *A Midsummer Night's Dream* at the venue in 1927. The theatre also served as a motion picture house for many years. One of the first films shown at the Metropolitan was *The Birth of a Nation*, while other titles included *The Rock Hard Breed* and the tug-at-your-heart-strings drama, *Purity*. No longer in use as a theatre, the building was demolished in 1937. Rochester has had many colorful theatres over the years. Among them were The Garden, The Chateau and the Majestic. In 1918 the Empress Theatre published the boast, "If you want a good show, the Empress should be your destination." That same year the Lawler Theatre was showing *Are You Fit to Marry*, with the disclaimer, "Acting upon the suggestion of the ladies who reviewed this picture at a private showing, no children under 16 will be admitted."

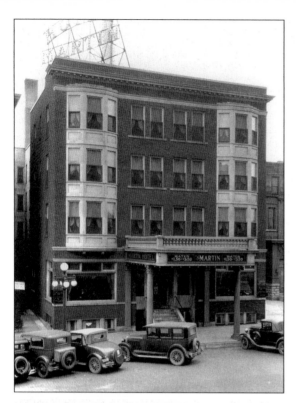

THE MARTIN. Seen here in the 1920s, the Martin Hotel was billed as "Rochester's finest medium priced hotel" with advertised room rates of $1.50 to $3.50 per day during the twenties and thirties. Located next door to the Y.M.C.A. on Second Street SW, potential guests were assured that it was "just a step from the Martin to everything in downtown Rochester." The Martin's facilities included a café and banquet rooms.

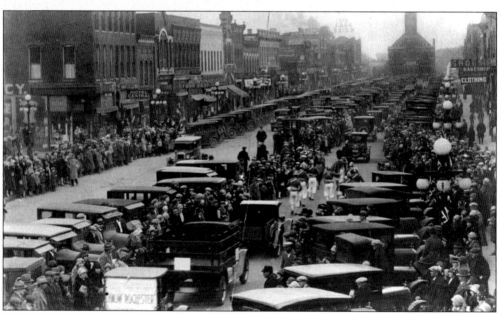

SPRING OPENING. "Nothing will be sold at the Spring Opening tonight but all salespeople will be at their usual places to display merchandise to visitors," announced the *Rochester Post Bulletin* on Thursday March 24, 1927. The non-sales event included prize drawings, two bands, two drum corps, two pianos carted about in the backs of two trucks, demonstrations by the Edwards School of Dancing, noisemakers, and a big parade of new 1927 model automobiles.

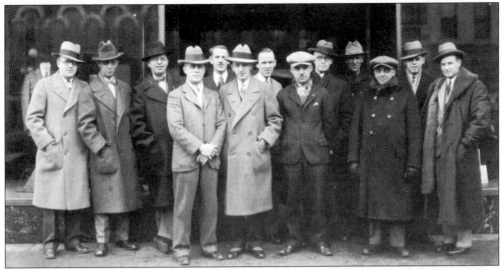

DAPPER FELLOWS. Prominent Rochester businessmen pose in February of 1928. From left to right are George Bernsten (Stevenson's), Earl A. Vine (Mortician), Arthur R. Nachreiner (Nachreiner Shoe Store), Lester Fiegel (First National Bank), E.H. Schlitgus (Olmsted County Businessmen's Association), Julius Estess (Lyman's Ready to Wear), Norton Lawler (Lawler's Dry Cleaners), Ron Trainor (Cook Hotel Cafeteria), Henry S. Adams (Adams Bookstore), George Morrison (Electric Supply Co.), Clarence E. Knowlton (Knowlton Co.), Harold F. Schmidt (Schmidt Printing Co.), and Fred Furlow (C.F. Massey Co.).

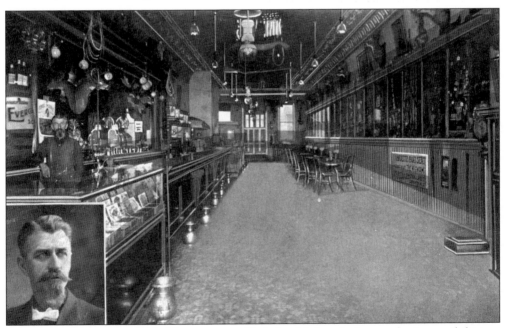

THE DRY YEARS. In 1919 Minnesota ratified the Volstead Act, enforcing prohibition. Authored by Minnesota congressman Andrew J. Volstead, the act banned the sale of alcohol. One year later Minnesota women, many of whom were proponents of prohibition, finally won their long fight for the right to vote. Pictured is a Rochester tavern known as Col. Fischer's Wigwam. Presumably it is Col. Fischer pictured in the lower left and behind the bar.

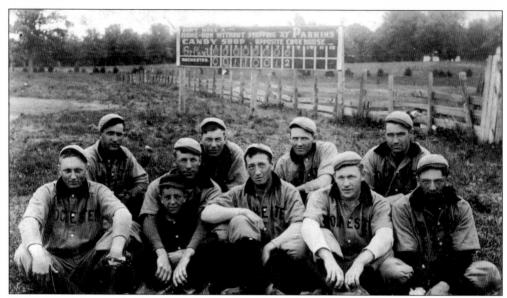

NATIONAL PASTIME. In the 1920s Rochester's top-notch local baseball team, the Aces, played at Mayo Field. In 1926, Mayor J.T. Lemmon, concerned that noise from the ballpark was disruptive to funerals held at the nearby Oakwood Cemetery, advocated moving the ball field to the fairgrounds. After some debate it was decided the fairgrounds were just too distant for Rochester fans to travel to. The Rochester team pictured is commemorating a five to zero victory over a St. Paul team.

SKYLINE TRANSFORMED. The construction of the Mayo Clinic's inspiring Plummer Building in 1928 transformed the city's skyline as shown in this photo from the period. Not part of the structure's original design, the tower of the Plummer building was added after construction had begun in order to house a 23-bell carillon. The Central School building, reduced to two-stories, is at left with the light colored Kahler Grand Hotel behind.

Four

MEDICAL CENTER

The world-renowned Mayo Medical Center has an origin as humble as the community of Rochester. Dr. William Worrall Mayo came to Rochester in 1863 when appointed an examining surgeon for the Union Army Enrollment Board. Mayo's two sons, William James and Charles Horace, began assisting him in his practice while still boys, eventually becoming physicians themselves. When Saint Marys Hospital opened in 1889 the three Mayo doctors constituted its entire medical staff, while several Sisters of Saint Francis saw to its daily operation and served as nurses. Over the next several years the Doctors Mayo became increasingly well known for their surgical expertise and both their practice and Saint Marys Hospital grew. By 1903 the name "Mayo Clinic" was officially adopted and in 1914 an impressive new building raised. Dr. Henry Plummer designed this first Mayo Clinic Building, also known as the Medical Block, with an aim toward facilitation of the integrated group practice of medicine. The Mayo Clinic, already a progressive force in American medicine, added to its stature with the construction in 1928 of the majestic edifice known as the Plummer Building, named in honor of its designer, Dr. Henry Plummer. Before and since that milestone achievement, there have been many other medical institutions in Rochester. Some directly associated with the Mayo Clinic and others not, but all filling a role in responding to the needs of the many patients from this or other cities and countries who have sought aid by coming to Rochester's medical center.

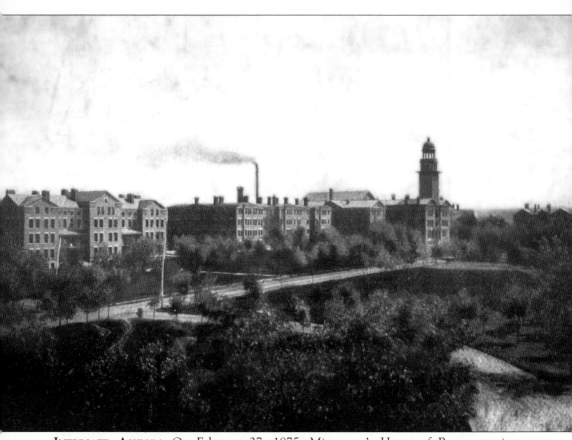

INEBRIATE ASYLUM. On February 27, 1875, Minnesota's House of Representatives was considering a bill that would place an intended Asylum for alcoholics, or "Inebriate Asylum" in Rochester. An argument was made against Rochester on the grounds that the small city had twenty saloons! Rep. Daniels, the bill's author, countered that the asylum should be constructed where it would do the most good. Rep. Fleming concurred, saying, "If patients should escape where they could get liquor, they would readily be secured again." Ultimately the institution was established in Rochester in 1879, becoming Rochester's first hospital. It was known for some time as the Second Minnesota Hospital for the Insane, and later as the Insane Hospital, and eventually the State Hospital. "Insane" was a loosely defined term during much of the institution's 104 years. People suffering from ailments such as mental illness, developmental disabilities, alcoholism, addiction, senility or a host of other maladies could find themselves irreversibly restricted there. Described in 1901 as a "city within a city" the State Hospital employed numerous staff and conducted a large farming operation that included poultry, dairy cattle and broad fields of vegetables, corn and alfalfa, all tended by employees and patients. The caves at Quarry Hill Park were used for the cold storage of State Hospital produce from the 1880s through the 1930s. The hospital's original buildings were razed in 1964 to be replaced by newer structures, some of which are now utilized by Olmsted County and the Federal Bureau of Prisons. The State Hospital was closed in 1982.

THE YOUNG MAYOS. Doctors Charles Horace Mayo (left) and elder brother William James Mayo are pictured standing in Saint Marys Hospital's first operating room, *c.* 1900. The two brothers jointly conducted the first surgery in the hospital, the urgent removal of a tumor from a patient's eye, on September 30, 1889. For several years they were the only attending surgeons at the hospital, operating once or twice each week.

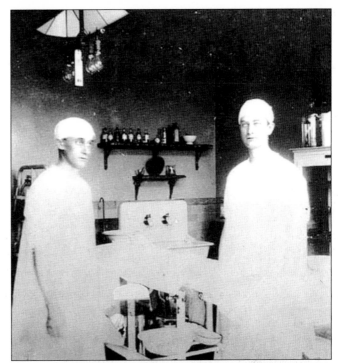

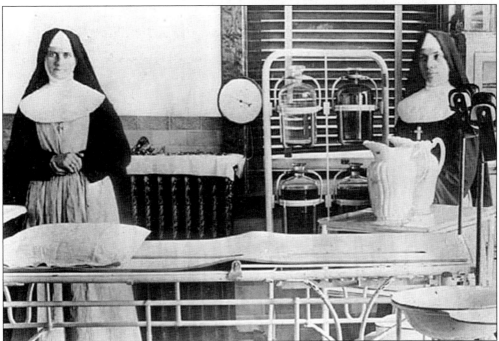

SISTER NURSES. The first Sisters of Saint Francis to staff Saint Marys Hospital were mainly teachers, not nurses. Still they rose to the challenge, dedicating themselves to the unfamiliar profession and the care of their patients. The Sisters learned basic nursing skills from Edith Graham, the only trained nurse in Rochester. Twelve Sisters worked at the hospital in its first year and six of those spent the rest of their lives as nurses there.

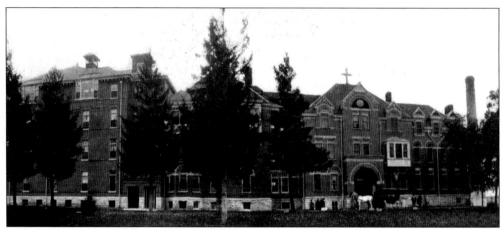

EXPANSION. The original Saint Marys Hospital was a 3-story structure built 40 by 60 feet and holding 40 beds in three wards with one private room. Oil lamps were used for lighting and the Sisters carried water by hand from the basement. Mother Alfred was the hospital's first administrator. Sister Joseph Dempsey officially became administrator in 1892 and continued in that post for an incredible 47 years. Pictured is Saint Marys Hospital in about 1910.

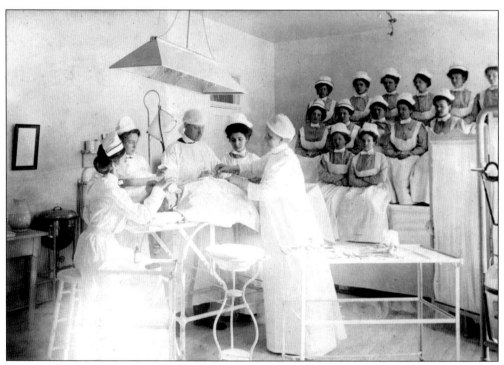

SISTER JOSEPH. Among the many remarkable accomplishments of Sister Joseph was the founding of the Saint Marys School of Nursing in 1906. During her tenure as administrator, Sister Joseph oversaw numerous expansions including the first in 1894, and others in 1898, 1903 and 1909, which raised the hospital's capacity to 360 beds, with six operating rooms. By 1922 Saint Marys had expanded to 650 beds with roughly 9,000 patients served each year.

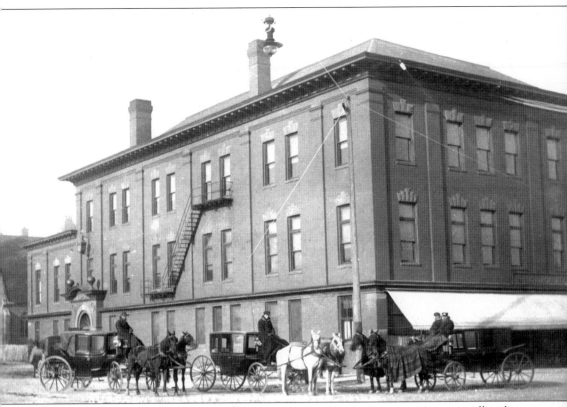

BEGINNINGS OF GROUP MEDICINE. With the Mayo medical practice growing rapidly, the Mayos added partners to help handle the patient load. In 1892 Dr. Augustus W. Stinchfield joined the Mayos, followed by Dr. Christopher Graham in 1894 and Dr. Melvin Millet in 1898. As the practice prospered more space was needed and a move to the Masonic Temple Building was made in 1901, the same year Dr. Henry Plummer joined the group. Other notable additions included Dr. Louis Wilson, who in 1905 was charged with development of the laboratories, Maud Mellish, hired to develop staff editorial services in 1907; and Harry J. Harwick, a local banker who took over business procedures for the group in 1908. This confederation of professionals was operating under a new system, which would become known as the group practice of medicine. "Even in the early day, through asepsis and antisepsis and other scientific advances, the scope of medical knowledge had already gone beyond the capabilities of any man to compass, or having such knowledge, to correlate the varied data and add them to clinical medicine," wrote Dr. William J. Mayo in 1933. "Therefore, in the early part of the twentieth century many additions were made to the staff of the Clinic in order to carry out the ideals which governed the organization." The Masonic Temple Building, which housed the Mayo practice from 1901 to 1914, is shown.

THE MAYO CLINIC. A group of medical professionals pose on the front lawn of Saint Marys Hospital in 1900. Dr. William J. Mayo is seated second from the left and Dr. Charles H. Mayo is seated third from the left in the second row. Late in his life Dr. Will explained the origin of the Mayo Clinic's name, writing, "The name 'Clinic' was given to the group by the medical profession, and was not one chosen by the growing staff. Owing to the fact that much of the teaching we were obtaining abroad and especially in Germany was that form of clinical instruction in which the patient was the center of the investigation, which in Europe had been given the name of clinics, it became the custom of the members of the profession who visited us to speak of the group as the 'Mayo Clinic'." The innovative practice with its ground breaking approach to cooperative medical endeavor led to a number of national firsts including the formation of specialties in orthopedics in 1912, neurology in 1913, thoracic surgery in 1915, dermatology in 1916, pediatrics in 1917 and neurological surgery in 1919.

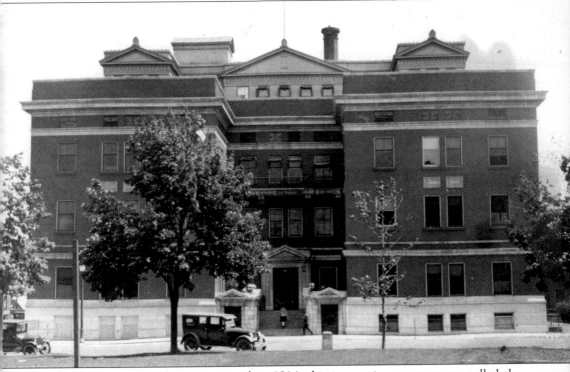

THE 1914 BUILDING. When constructed in 1914, this innovative structure was called the Mayo Clinic Building but later became known as the 1914 Building. By 1912, the rapid growth of the Mayo Clinic's practice called for expansion. It was decided that a new building must be constructed. Responsibility for the design of the new facility was put into the capable hands of Dr. Henry Plummer. A brilliant and inventive physician, Dr. Plummer had joined the practice in 1901. The designs he executed for the building were focused around the Mayo Clinic's new form of cooperative medicine. All areas of the practice, from offices and laboratories to support services and accounting, were brought together under one roof. Innovations introduced by Dr. Plummer included a conveyor belt system that allowed patient files to be quickly transferred between floors, a color coded signaling system for indicating activity in exam rooms, a telegraph ticker that routed specific calls to individual physicians and the first large intercommunicating telephone system in the United States. The building was constructed on the site of Dr. William Worrall Mayo's original 1863 homestead. Dr. Will said in 1914, "It is the hope of the founders of this building that in its use the high ideals of the medical profession will always be maintained. Within its walls all classes of people, the poor as well as the rich, without regard to color or creed, shall be cared for without discrimination."

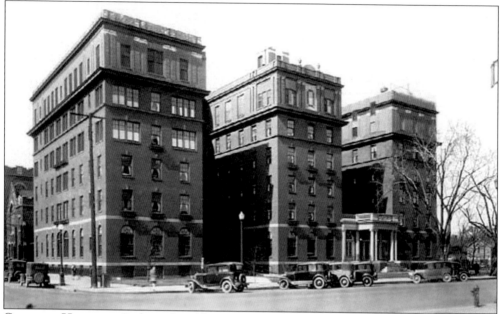

COLONIAL HOSPITAL. Built as a hotel but converted for use as a hospital before it even opened, the Colonial eventually became known as the Methodist Hospital. Only the northern most (far right) of the three blocks pictured still stands. Several 'lost' hospitals once served Rochester; among them were the Stanley Hospital, the Worrell Hospital and Dental Annex, the Detention Hospital on the State Hospital grounds, and the Curie Hospital.

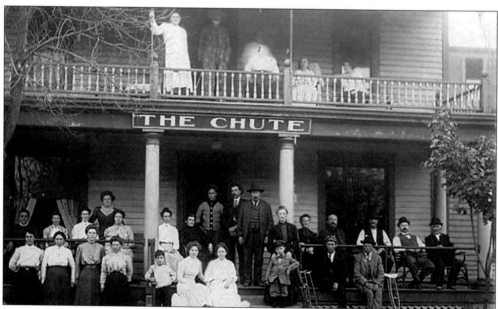

SANITARIUM. Guests and staff of the Chute Sanitarium pose, c. 1910. Today the word "sanitarium" is somewhat troublesome, seeming to have a meaning identical to "insane asylum." However, in the nineteenth century the typical sanitarium was generally a hospital or residential health spa or tuberculosis hospital. Rochester's Chute Sanitarium provided a variety of health services to Rochester citizens and visitors for many years.

SUBWAY SYSTEM. The Diet Kitchen of the Curie Hospital is shown here in the mid-1930s. Note the entrance and signage for the subway system at lower right. The Kahler Corp. built Rochester's first walking subway between the Kahler Grand Hotel and the 1914 Building in the 1920s. Ellerbe Architects executed the subway design in cooperation with Dr. Henry Plummer. By 1924 the Curie Hospital, Fisher Cafeteria, Damon Hotel, Zumbro Hotel, Colonial Hospital and Worrall Hospital were all linked via subway.

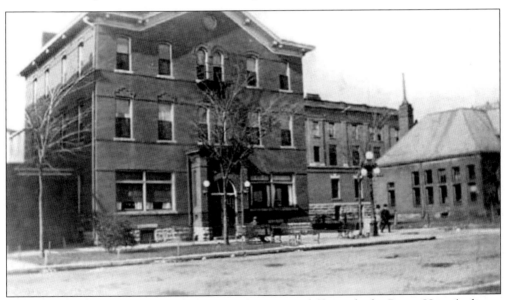

OLMSTED COUNTY HOSPITAL. The New Rochester Hotel (formerly the Pierce House), shown here in 1925, served as Olmsted County Hospital from 1921 to 1926. A later Olmsted Community Hospital was established after World War II to attract general practitioners to the area. A $750,000 bond was issued and a parcel of State Hospital land provided by the state. The hospital was completed in 1955 and Dr. Harold Wente established Rochester's Olmsted Medical Group in the early 1950s. The "Red Brick" Rochester Library building is seen in the foreground at right, with the old Y.M.C.A. building at right rear.

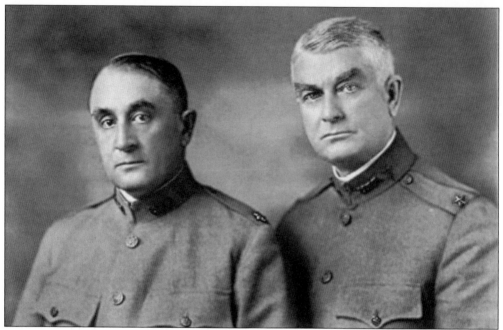

UNCOMMON PHILANTHROPY. Driven by their shared philosophy of philanthropy, the Mayo brothers (pictured *c.* 1918) dissolved their business partnership in 1919 and turned over the Mayo Clinic's name and assets to a new not-for-profit entity known as the Mayo Foundation. The gift included a large portion of their collected personal wealth. "The important thing in life" wrote Dr. Will, "is not to accomplish for one's self alone, but for each to carry his share of collective responsibility"

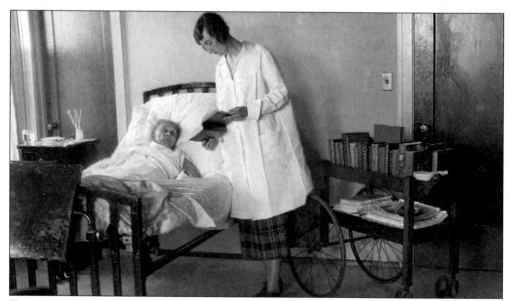

TRAVELING LIBRARY. A Mayo Clinic patient receives a visit from the traveling library in 1925. The care of their patients was always foremost in the minds of the Mayos, a philosophy of compassion shared by the Sisters of Saint Francis and encouraged among all the organization's staff. "The best interest of the patient is the only interest to be considered," said Dr. William J. Mayo.

ON THE RISE. The Plummer Building, named for Dr. Henry S. Plummer, takes shape in 1927. Ground breaking for construction was on July 10, 1926, and the building was completed in 1928. Dr. William J. Mayo maintained that hiring Dr. Plummer was the best day's work he ever did for the clinic. Dr. Plummer's contributions included the dossier medical records system and the design concepts for both this clinic building and the 1914 Building.

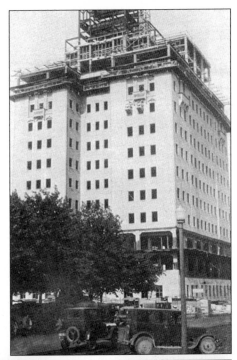

KAHLER'S CONTRIBUTIONS. The Kahler Corporation started as a hotel company but expanded into hospital operations as a natural extension of services in Rochester's highly medical environment. Among the properties owned and operated by the corporation were the Hotel Kahler, Hotel Zumbro, Stanley Hotel, Damon Hotel, Kahler Hospital, Worrall Hospital, Colonial Hospital, Kahler School of Nursing, Model Laundry, Zumbro Cafeteria, and the Rochester Diet Kitchen in the Curie Hospital. Pictured is the Basal Metabolism Laboratory in Kahler Hospital *c.* 1932.

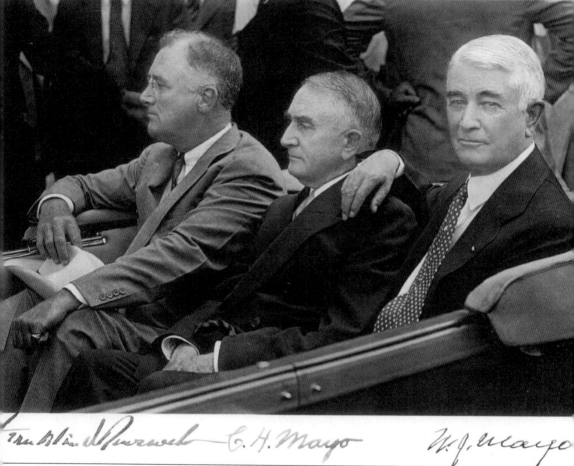

Franklin D Roosevelt — *C. H. Mayo* — *W. J. Mayo*

WORLD FAMOUS SURGEONS. From left to right are President Franklin D. Roosevelt, Dr. Charles H. Mayo and Dr. William J. Mayo riding through the streets of Rochester on August 8th, 1934. Long before their retirements, Dr. Will in 1928, and Dr. Charlie in 1930, both had gained a status of recognition in the medical profession and the world at large that few people ever attain. Yet it is clear that fame and wealth, though achieved, was not the goal of either of these great physicians. The two brothers were nearly inseparable in life having, as Dr. Will put it, "absolute mutual confidence" in each other. They built the Mayo Clinic and its associated entities up through the implementation of honorable, disciplined and innovative practices that steadfastly adhered to their father's doctrine of "social obligation" to one's fellow citizens. Dr. Charles H. Mayo died on May 26, 1939. His elder brother, Dr. William J. Mayo, followed him just two months later on July 28, 1939. In 1934 President Roosevelt praised the two physicians with the tribute, "You are beloved at home and abroad and a world deeply in your debt gives you inadequate return in external honors and distinctions. But your true distinction is in the simple fact that you have put men's sense of brotherhood and interdependence into a new setting and have given it a new meaning." Dr. Charlie himself once said, "If we excel in anything, it is our capacity for translating idealism into action." Today the world-renowned Mayo Medical Center continues to stand tribute to the actions of these two benevolent idealists.

Five

TRANSPORTATION

"What can be more palpably absurd than the prospect held out of locomotives traveling twice as fast as stagecoaches?" asked one newspaper in March of 1825, and who could blame them for their skepticism, no matter how mistaken their prediction? After all, steam power was in its infancy and overland travel in 1825 was based on the motive power of the horse. A situation largely unchanged from a thousand years earlier. The amazing leap forward in transportation came mostly in the years after Rochester's founding. The first settlers to reach Rochester in 1854 came via plodding wagon teams, but just ten years later the city was transformed by the arrival of the Winona & St. Peter rail line with its fast and reliable transport. The turn of the century produced the automobile, and wagon teams were forced to share Rochester's streets with noisy new automotive contraptions. Even more miraculously, the teens and twenties brought air travel, a wonder of science that would certainly have raised shouts of outraged disbelief in 1825. As transportation changed, so did the face of the community. The passenger train replaced the stagecoach. Harness and blacksmith's shops gave way to garages and gas stations, buggy shops became car dealerships and Rochester established its first airfield. With each new decade automobiles became faster and more reliable, increasing demand for improved roads. Dirt and gravel lanes were replaced by sleek blacktop, and highways displaced buildings as a modern city took shape where Native travois had marked the prairie just a century before.

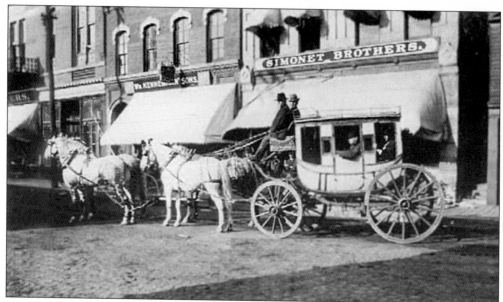

STAGE COACH. In July of 1854 the M.O. Walker Stage Line, with service along the Old Dubuque Trail between St. Paul and Dubuque, Iowa, opened a station in Rochester. Stages like this one, shown in Stillwater, Minnesota in 1864, ran regularly carrying mail, passengers, and freight. The Northwestern Stage Company also served Rochester in the 1850-60s and advertised, "None but temporate and safe drivers are employed on this route." Drinking and driving was apparently a significant issue of the day. M.O. Walker similarly advertised that his drivers "nver took a draft of strong waters" while on the stages. He also boasted that they were "the most courteous and considerate of mortal men.

HAY WAGON. Rochester's early economy depended heavily on the success of area farmers, and the farmers depended heavily on the teams of oxen or horses that provided them power and transportation. Here a farmer plies his pitchfork to load hay onto a horse drawn wagon. The 1870 census showed 9,829 horses and mules owned in Olmsted County, which amounts to one horse or mule for every two people in the county at the time.

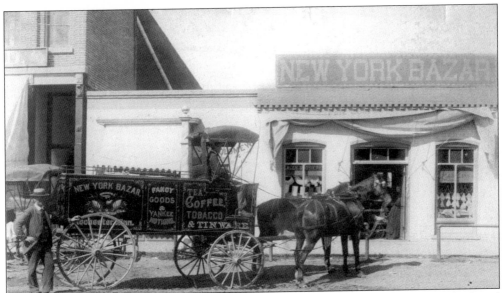

MERCHANT WAGON. In 1874 a Minnesota publication noted of Rochester, "The thrift and enterprise, wealth and hospitality of its citizens are known far and wide." Here an enterprising merchant poses alongside the New York Bazar wagon, team and store at 13 West Zumbro Street (now Second Street SW) in September of 1890. Mrs. W.S. Elkins owned the business, which advertised "Fancy Goods, Yankee Notions, Tea, Coffee, Tobacco and Tin Ware."

THRESHING MACHINE. Steam powered threshing machines, while a significant agricultural advancement, still required large crews to handle their operation. Family, neighbors and hired hands joined in during harvest to cut the grain, stack the shocks for drying, and then collect the dry shocks of grain and feed them into the threshing machine. Workers were also needed to operate the steam engine that powered the thresher and handle the teams of horses required to haul the wagonloads of grain.

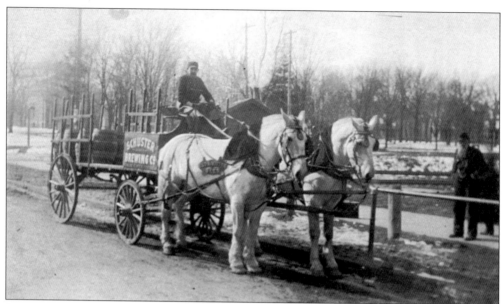

SCHUSTER'S TEAM. The Schuster's Brewery was established in Rochester in 1865. Here the Schuster's Red and White Beer team pauses on its rounds. Such teams made deliveries throughout the city and were indispensable to local commerce. Color Matched teams, such as this one, were highly valued and a source of pride for their owners.

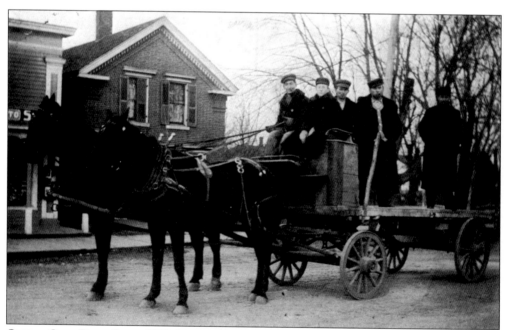

QUEEN CITY DRAY LINE. Will Cowan, (far right) poses with his crew and team in 1917. Mr. Cowan was owner of the Queen City Dray Line. Dray lines were a staple of every community, hauling all manner of furniture and goods to and from the rail depots, between businesses, and from stores to homes as needed.

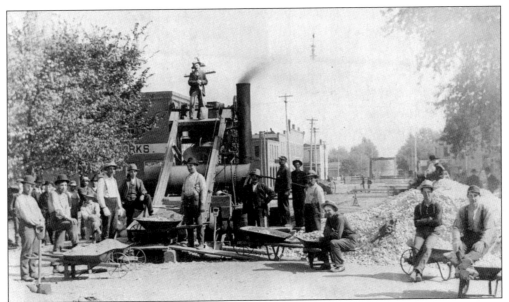

HARD LABOR. As Rochester grew, ordinances were put in place in response to some unorthodox pioneer behavior. Prohibited activities included, "Willfully or wantonly" driving "any team, horse, ox or mule onto, along or across sidewalks," and allowing bulls to "run at large" within city limits. An 1871 ordinance allowed any male convict failing to pay their fine to be sentenced to "hard labor" working on the city streets. Pictured is an early Rochester street crew, legal status unknown.

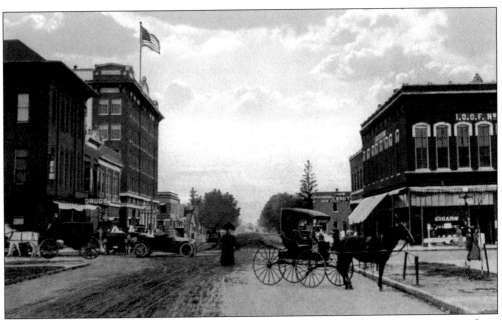

SHARED ROADWAYS. Foreshadowing the end of the era of horse drawn transportation, here buggies and carriages share Rochester's streets with automobiles. The Masonic Temple is at left and the Odd Fellows Building at right. The five-story Zumbro Hotel can be seen flying the American flag at left rear.

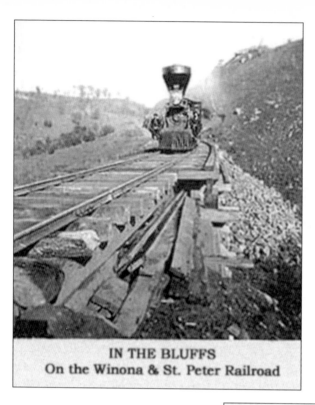

IN THE BLUFFS
On the Winona & St. Peter Railroad

THE WINONA & ST. PETER RAILROAD. Long awaited and tremendously important to the local economy, the railway from Winona to Rochester was finally completed in October of 1864. The event caused the local press to exclaim, "JUBILATE! JUBILATE! – That is what everybody and his wife ejaculated on hearing last week for the first time in Rochester, the whistle of the locomotive on the Winona and St. Peter Railroad, now completed and in running order to this city." An engine of the Winona & St. Peter RR makes its way toward Rochester through the Stockton Hills, c. 1865.

OBSTACLES OVERCOME. The treacherously steep and unforgiving Stockton Hills, which made wagon travel between Rochester and Winona an inconvenient and even dangerous adventure, had been a thorn in the side of commerce since Rochester's founding. Therefore it was with much joy that David Blakely, editor of the *Rochester City Post*, reported on October 8, 1864, "we bid adieu to the Stockton Hills, and the weary and everlasting jolting and poundings, and aches and pains, and inward revilings and objurgations which they have caused us." The rails of the Winona & St. Peter Railroad pass through a portion of the Stockton Hills, c. 1865.

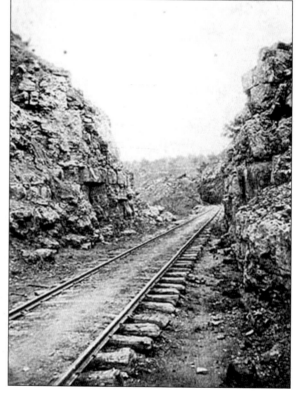

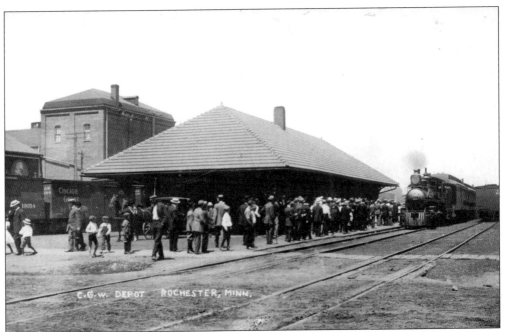

CENTER OF COMMERCE. In 1864 J.V. Daniels made the first shipment of freight from the Winona & St. Peter R.R. depot on Fourth Street (later the Winona & Western and finally the Chicago & Great Western R.R. Depot). In 1874 it was reported that, "Rochester has become one of the great points in the world for the primary shipment of wheat, more than 1,000,000 bushels being here received in the year 1873."

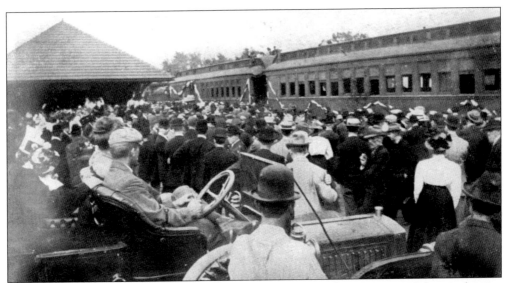

FUNERAL TRAIN. A crowd sees off the funeral train for the late Governor Johnson, leaving Rochester on September 21, 1909. Elected Governor of Minnesota in 1905, he was a candidate for the Democratic nomination for President in 1908. The Governor died in Rochester on September 20, 1909 and was mourned with the headline, "THE STATE AND NATION BEREAVED, Governor John A. Johnson, the Idol of the State, the Hope of the Democracy, the Man, Called to the Great Beyond."

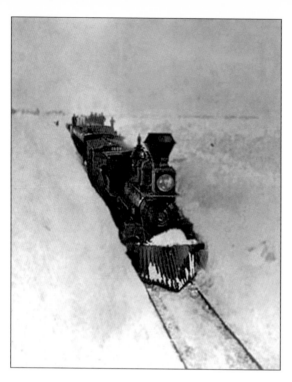

SNOW BOUND NO LONGER. After an arduous process of digging out, a Chicago & North Western train resumes its winter tour, *c.* 1881. Well into the twentieth century the lack of modern equipment often caused trains to be stranded by Minnesota's heavy snowfalls. Hard labor by numerous linemen was required to resolve such stranding. The numbing work was generally performed for wages of about one dollar a day.

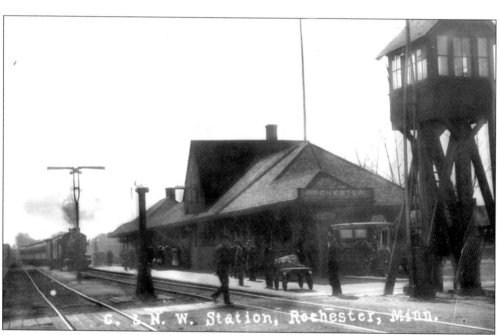

CHICAGO & NORTH WESTERN. Built in 1890 and located along what is now Civic Center Drive, the Chicago & North Western Train Station served passengers and freight customers for over seven decades. An early railroad promoter counseled area farmers, "Twenty Cents saved in sending a bushel of wheat to market adds Five Dollars to the yearly product of an acre of wheat land." The last passenger train left the depot July 23, 1963, and the structure was razed in 1989.

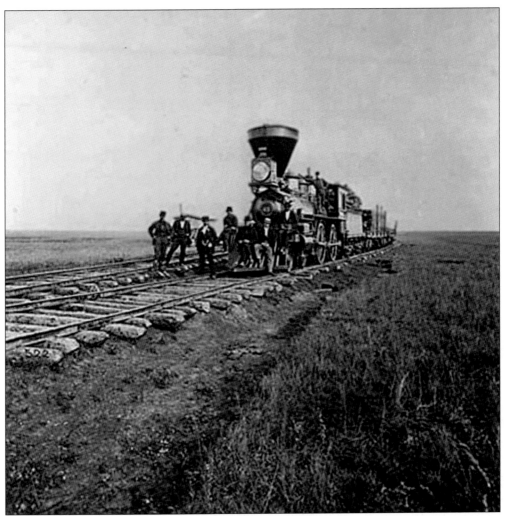

DEADLY DISPUTES. The Winona & St. Peter line was completed into Rochester in 1864, but the railroad had already caused a deadly conflict five years earlier. In 1859 grading for the Winona & St. Peter line was underway in North Rochester and was slated to cross the property of one of Rochester's earliest settlers, Thomas C. Cummings. Despite the commercial importance of the railroad, Mr. Cummings was adamantly against surrendering a portion of his land for the railway's access. A confrontation between Cummings and the railroad's grading foreman, Bill Messler, became so hot that Messler lost his temper and shot Cummings dead. The killing enraged the local citizenry. With lynch mob mentality brewing, the authorities hurriedly relocated Messler to Winona via a fast team of horses. The shooting was the young city's second homicide. The first occurred in the spring of 1858 when a man was stabbed in a saloon on Broadway Avenue following a quarrel over a card game. Shootings and killings were not common in Rochester, and yet they were certainly not unknown on the frontier. Claim jumping alone led to numerous conflicts, some involving gun play, and although Minnesota has never been synonymous with the wild west, still it was just north of Rochester in Northfield, Minnesota that one of the greatest shoot outs of the wild west era occurred. On September 7, 1876 the notorious James/Younger gang attempted to rob the First National Bank in Northfield. In the ensuing gun battle with townsfolk three outlaws were killed and the others badly wounded. Two Northfield citizens were also killed. Ultimately only Jesse James and his brother Frank escaped.

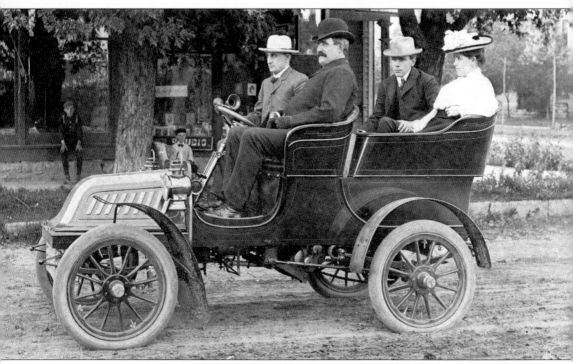

INNOVATIVE AUTOIST. Dr. Charles H. Mayo (front seat with white hat) and friends are pictured here in a Thomas Flyer, *c.* 1902. Owning a horseless carriage in 1902 was considered more of a statement of wealth than practicality. The vast majority of Rochester's citizens still got around via horse drawn conveniences. Many groups were opposed to the automobile and the noisy, smelly, horse frightening menace they perceived it to be. So fervent was anti-automobile sentiment that numerous localities enacted outrageous laws in not-so-subtle attempts to force automobiles off the road. In Pennsylvania the Farmers Anti-automobile Society put forth a set of regulations that included, "In case a horse is unwilling to pass an automobile on the road, the driver of the car must take the machine apart as rapidly as possible and conceal the parts in the bushes." Dr. Charles H. Mayo was, however, an innovator, and it is not surprising that he took to operating an automobile early despite the disapproval of some critics. Early in the 1900s enthusiasts of the new craze organized an auto club in Rochester. Among the helpful suggestions made to members was an advisory to, "keep on the right side of the street and to make a long turn when rounding corners." In 1912 the fledgling American Automobile Association provided drivers with information and support. Among the road gear recommended to motorists were, "a shovel and axe, a hundred feet of 3/4 inch rope, block and tackle, and a tarpaulin."

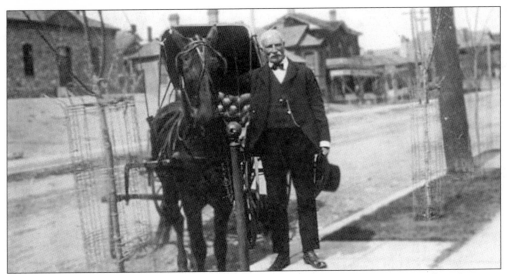

TRAVELING DOCTOR. Unlike his son Charles, Dr. William Worrall Mayo numbered among the majority still content to travel by horse and buggy in 1904. William W. was married to Louise Abigail Wright in 1851. Louise Mayo followed her physician husband to Rochester in 1864 where her son William James was born a year later. Dr. W.W. Mayo passed away on March 6, 1911 at the age of 91.

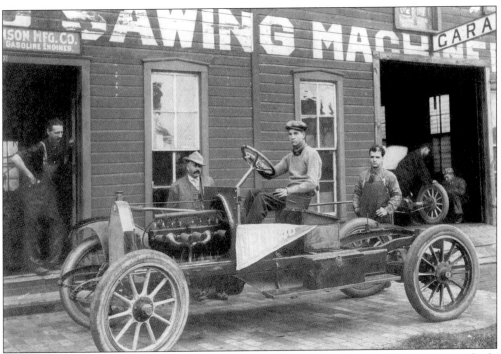

STRIPPED FOR SPEED. Carlos Ellis sits behind the wheel of this stripped down motor vehicle outside the Ellis Motor Company garage in Rochester. Frequently automotive garages near the turn of the century were converted implement or wagon shops. At one time Rochester boasted several such shops including wagon and buggy manufacturers. In time however, all gave way to the changing transportation landscape.

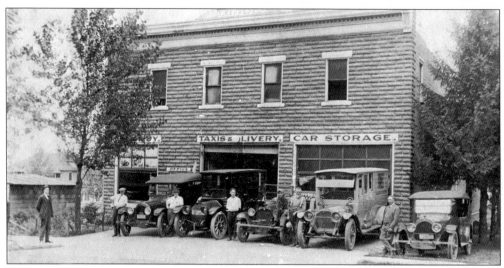

TAXIS & LIVERY. Still in transition from horses to cars, Kennedy Hack and Baggage Lines offered car storage and livery services, *c.* 1916. Five years earlier the Eaton Hack Line switched from horse drawn hacks to automobiles. W.L. Eaton had established the Eaton Line in 1911. The building pictured was located across from Saint Marys Hospital and was razed in 1955. The truck pictured second from the right is an early ambulance.

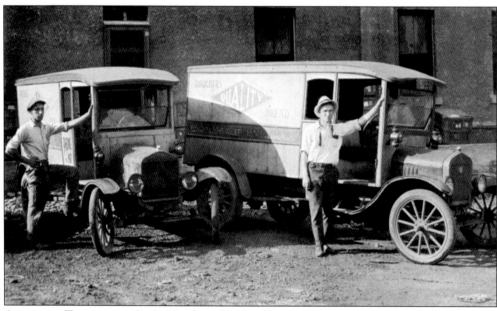

ACCEPTED TRANSPORT. By 1918, when the First World War ended, automobiles had become largely accepted as the transport of choice for most city businesses. Horse teams were still in use as late as the 1930s but on a limited scale. These delivery trucks owned by the Thatcher Wholesale Bakery seem to have steering wheels mounted mid-cab. Clyde L. Crume (left) is pictured with an unidentified Thatcher driver.

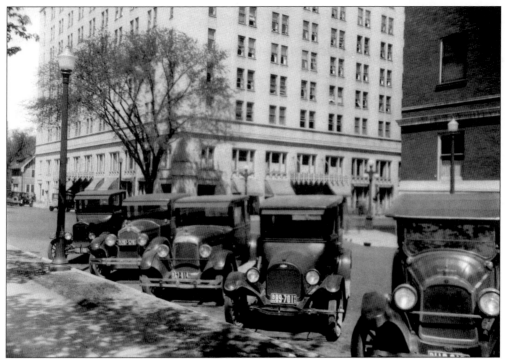

ANY COLOR AS LONG AS IT'S BLACK. By 1914 American automobile manufacturer, Henry Ford's improved assembly line allowed the Ford Model T to be assembled in just ninety-three minutes. Reduced assembly time meant reduced production costs. Other automakers followed suite bringing the price of cars within reach of the general public. A collection of early autos sits on Second Avenue West in about 1926. The Kahler Hotel is at left and the Mayo Clinic's 1914 Building at right.

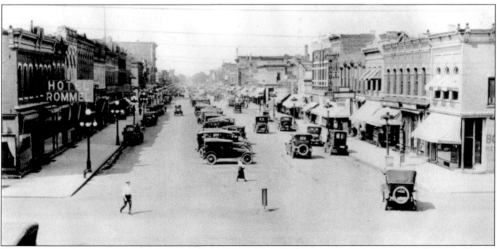

DOWNTOWN PARKING. A glance at this photo of Broadway Avenue shows just how different Rochester's automobile situation once was. There is parallel parking on both sides of the street as well as a central parking aisle. Additionally, no streetlights are in evidence and the only road signage seems to be the small placard in the middle of the intersection. Finally, the man at left seems comfortable crossing the intersection kitty-corner!

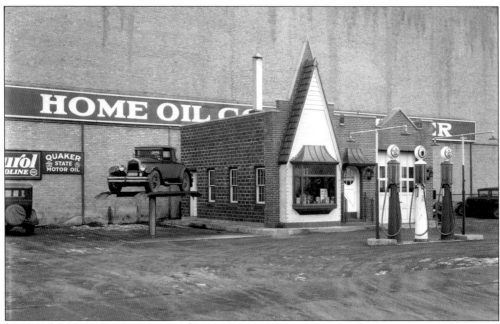

MAINTENANCE OR REPAIR. A two-door coup gets a lift at the Home Oil Company station. The handsome little station was located at 1301 North Broadway. Numerous filling and service stations sprang up around the city during the automobile boom of the teens and twenties. Some were short lived while others provided decades of service to the community.

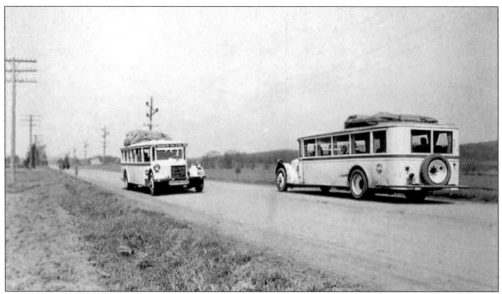

DIRECT CONNECTIONS. Two Jefferson Transportation Company buses meet on the road north of Rochester in 1925. The dirt road they are traveling is now Highway 52. These buses made four trips daily from Rochester to Minneapolis with stops in Pine Island, Zumbrota, Cannon Falls, Farmington and St. Paul. The company also offered direct connections to "Duluth, Virginia, Hibbing and all Range towns" as well as "points in Northern Minnesota" and west.

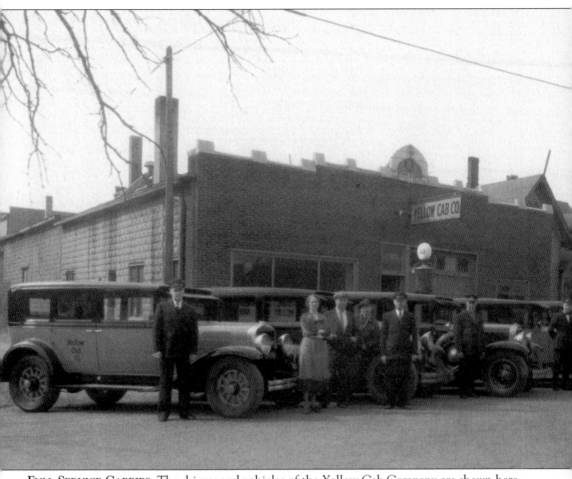

FULL SERVICE CABBIES. The drivers and vehicles of the Yellow Cab Company are shown here, *c.* 1934. The business was located at 112 East Center Street and owned by brothers William L. and Burt W. Eaton. Besides conveying visitors and other passengers around Rochester, the Yellow Cab Company augmented the resources of the Rochester Police Department for many years. The Police Department didn't purchase its first vehicle until 1920. Prior to that time Yellow Cabs were used to respond to police calls and to transport prisoners. Even after 1920 the practice continued as the vehicle purchased in that year was a motorcycle. A second motorcycle with sidecar was purchased by the city in 1922, but it was not until 1929 that the department purchased its first car, a Whippet sedan. When the Olmsted County Bank and Trust Company was robbed on December 4, 1926, the police responded by taxicab. Several perpetrators burst into the bank wielding guns and demanding silence. A bank officer, Charles F. Dabelstein, defied the robbers and was struck down with a blow to the head. The bank's alarm system, which should have signaled for armed assistance from volunteer Rangers at the city's other banks, failed to operate and the thieves escaped the building. A number of shots were fired during the incident and two police officers were shot and wounded. The entire police department turned out, and the Rangers and local militia were also activated. Several of the Eaton's Yellow Cabs were called into service during the ensuing investigation. Eventually one of the robbers was caught and convicted of the crime. His accomplices were never brought to justice.

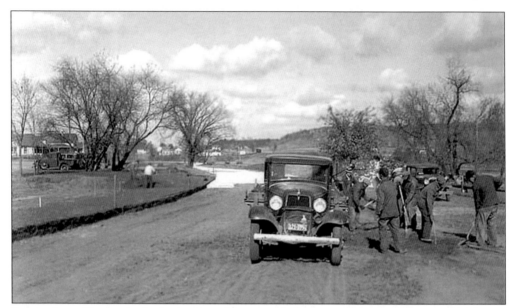

SILVER LAKE ROAD. At the beginning of the twentieth century there were no paved highways between cities or maps of existing wagon roads. The automobile age changed all that and despite wide differences in the methods, quality and scope of road construction and maintenance between localities, roadways were expanded and improved throughout the region. Here a new road is laid around Rochester's Silver Lake in October of 1936.

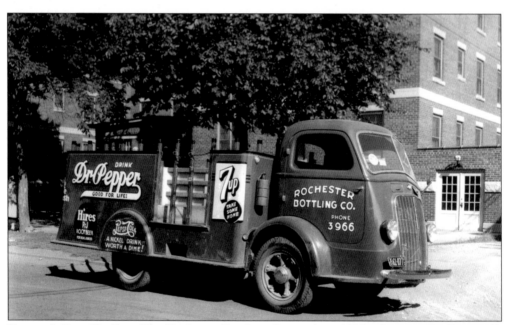

DRINK A BITE TO EAT. This Rochester Bottling Co. truck, *c.* 1937, advertises Dr. Pepper, 7-Up, Hires Root Beer and Pepsi-Cola. A Rochester Bottling Co. advertising campaign of the period advised, "Energy lags at 10, 2 and 4 o'clock. When you feel that between-meal letdown, take time out for Dr. Pepper" and "Drink a bite to eat." The truck pictured is a Model D300 International Harvester.

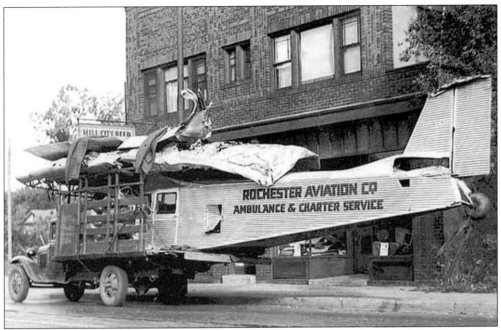

EARLY AIRFIELDS. In the 1920s a group of local businessmen rented a farmer's field west of Rochester, which accommodated barnstormers, crop dusters, and charter flights. Jefferson Transportation Co. flew two flights daily to and from the Twin Cities. Eventually a second airfield, located on property later occupied by Seneca Foods and the County Fairgrounds, became the primary aviation center for Rochester. It was called Graham Field. Pictured is a Rochester air ambulance and charter plane, c. 1930.

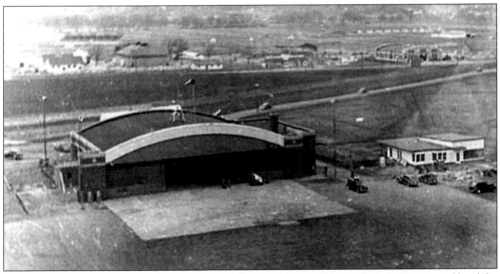

LOBB FIELD 1940. In 1928 Mayo-owned Rochester Airport Co. purchased 285 acres of land for a new and expanded airfield. Called Lobb Field, the new airport was largely located between 13th and 20th Streets SE and Third and 13th Avenues SE. Scheduled airline service to the Twin Cities and Chicago began in 1928 and Air Mail service was introduced in1930. During World War II military flights carrying war supplies to Russia regularly stopped at Lobb Field for refueling.

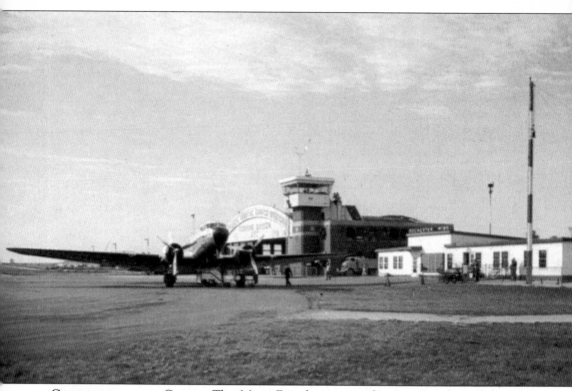

CHANGING OF THE GUARD. The Mayo Foundation turned over ownership of the airport enterprise to the City of Rochester in 1945. This allowed the airport to receive additional funding unavailable to privately held airports. In 1957, with Lobb Field rapidly becoming inadequate for Rochester's aviation needs, work began on a larger airport seven miles south of the city. Dedicated in 1960 the airport was called the Rochester Municipal Airport. The new airport was originally equipped with two blacktop runways with lengths of 4,000 feet and 6,400 feet respectively. The blacktop surfaces were unable to withstand the combination of heavy use and Minnesota's temperature extremes and had to be replaced by concrete within the first several years.

The advance of air travel and the continued improvement of automobiles and roadways during the twentieth century brought a close to the age of passenger trains. On September 30, 1965, a lone Chicago & Great Western passenger train rumbled along the tracks out of Rochester for the last time. The great trains were broken up, the engines placed in other service and the passenger cars relegated to graveyards of rusting obsolescence.

Six

FIRE AND FLOOD

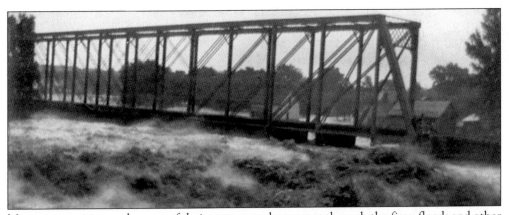

Most communities mark a part of their passage to the present through the fires, floods and other disasters they have endured. For Rochester these unfortunate events have included the Central School fire, railroad fires and numerous church fires, the devastating tornado of 1883, the massive floods of 1903, 1908, 1925 and many more. Intertwined with these events is the history of the fire fighters and citizens who took part in responding to these challenges. On January 22, 1866 the Rochester City Council authorized R.B. Graham, O.P. Stearns and G.C. Cook "to recruit and accept such persons as they shall deem suited for the organization of a Hook, Ladder, and Bucket Company." This first fire company was intended to number fifty members and was furnished with "hook, ladders, buckets and all other necessary equipment at the expense of the City." At the same time three Fire Wardens were appointed and charged with the duty "to personally examine and inspect all stores, stove pipes, chimneys and other fixtures in and about each and every building with reference to the security of same in regard to accidental fires." Over the years numerous improvements and expansions to the city's fire defense were made including the construction of five successive fire stations in Rochester's downtown—1870, 1890, 1898, 1930, and 1995. Hundreds of dedicated volunteers and professional fire fighters have served the community, their tenures spanning the full gamut of fire fighting techniques including the bucket brigade, push cart pumps, stationary pumping units, horse drawn fire engines and finally the now venerable fire truck.

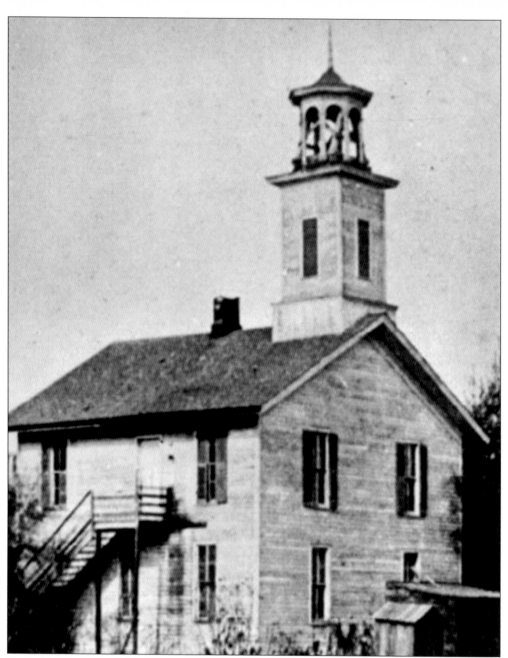

FIRST FIREHOUSE. Rochester's first firehouse was completed on October 8, 1870 south of Third Street SE on the west bank of the Zumbro River. Its construction corresponded with the organization, on July 2, 1870, of Rochester's first volunteer fire department. The city council purchased one stationary pump, one Silsby "Little Giant" Portable Steam Pump, three hose carts and 2,000 feet of fire hose at a cost of $9,750. The stationary water pump was located in the Olds and Fishbach Mill, at Third Street SE and the Zumbro River close to the fire station, and was powered by the mill's water wheel. The "Little Giant" was located in the fire station directly over the millrace. Trap doors in the floor gave access to the water below for suctioning water from the river and for safely dumping ashes from the engine.

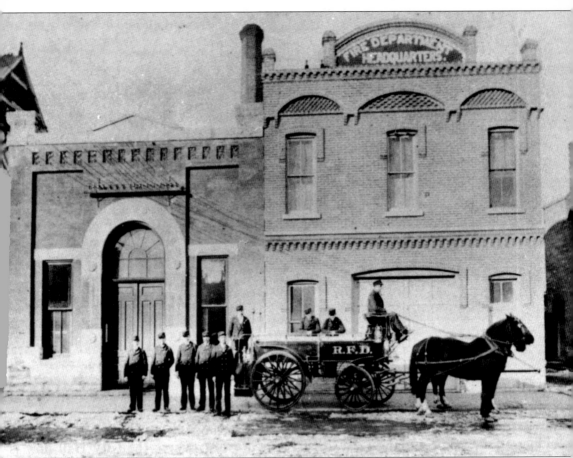

ELECTRIC PLANT AND FIRE HOUSE. The Rochester Electric Light Plant is seen at left, and the Rochester Fire Department Headquarters at right, *c.* 1894. The two buildings stood on Third Avenue SW just east of the City Hall. The electric light plant was Rochester's first public utility. Its construction was approved by the city council in 1892 after extensive debate and completed in 1894 at a cost of $21,000. The plant began generating electricity, lighting streetlights on Broadway, on the evening of March 14, 1894, under the supervision of A.C. Sprout, a Western Electric construction foreman. Curious citizens gathered in a mild snowfall to admire the lights and watch the activity in the new plant. The Fire Department Headquarters building was built in 1890. The team of horses pictured is the first team employed by the fire department. They were rented for this purpose from Richard Ryan. Previously the fire department had relied on hand carts pushed and pumped by the fire fighters. The combination of duties could be exhausting. "Whenever there was a large fire the regular firemen would soon tire of working on the brakes and they would appeal to the spectators to relieve them for a short time," reported a fireman of the era. The Fire Department vacated this building when the new Central Station was completed in 1898 and the Light Plant expanded into the space. Both structures burned down in October of 1915. Pictured from left to right are William Murray, William J. Hall, Bill Cudmore, Charles Zimmerman, William Boylhart, Henry (Stony) Jacobs, unidentified, Jack McHugh, and Jack Ryan.

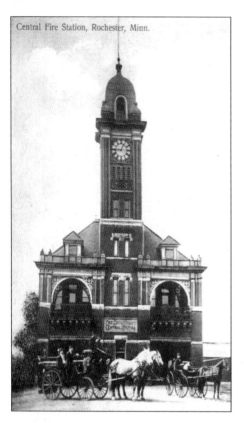

Central Fire Station, Rochester, Minn.

CENTRAL STATION. The Fire Department Central Station was built on solid rock in 1898 just south of Fourth Street SW and directly on Broadway Avenue. An impressive clock tower topped the structure. Seth Thomas created the bell tower's clock at a cost of $3,500. The instrument was installed under the supervision of alderman and city engineer, C.A. Joslyn. The structure was the third fire station to be built downtown.

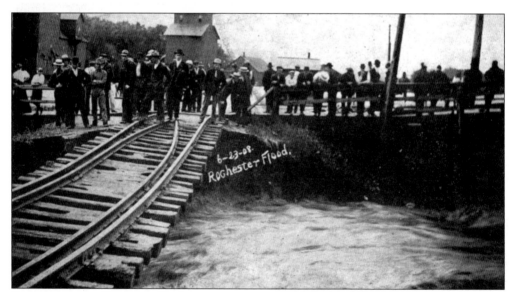

SURVEYING THE DAMAGE. Rochester experienced one of its worst floods on June 23, 1908, when the Zumbro River, already swollen by rains, surged over its banks and inundated the town. So swiftly did the waters rise "that parties driving on Cascade road were compelled to leave their rig and take refuge in trees," reported the Post and Record. The ruined C. & G.W. R.R. Bridge is pictured.

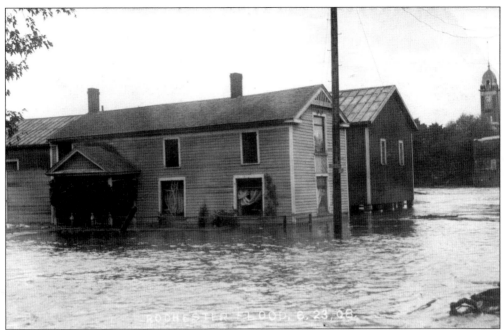

Utilities Impeded. 1908's "raging torrent" knocked the "electric power house" out of commission and submerged the entire water works plant extinguishing the plant's boilers. The Schuster Brewery trucked emergency water to Saint Marys. An earlier flood also submerged the water plant in 1903. During that flood an indomitable engineer reportedly leapt into the head high waters and used his feet to adjust the pump values. Other major floods struck the city in 1925, 1951 and 1978.

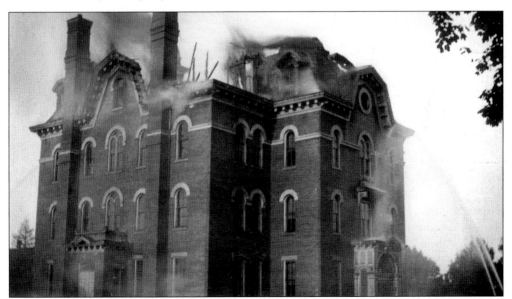

Central School and Alarm. In 1879 the Central School served as the alarm center for the entire city. The night watchman and fire department officers held keys to the school building within which they could ring the school bell to sound the alarm when needed. This system was no longer in use when the Central School burned in 1910, having been replaced by a call box alarm system in 1886.

95

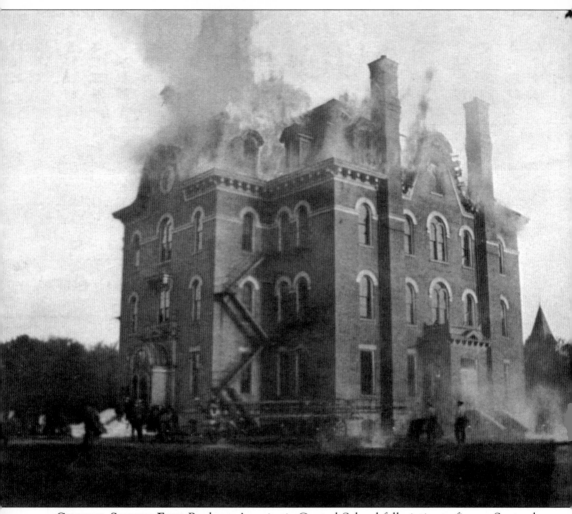

CENTRAL SCHOOL FIRE. Rochester's majestic Central School fell victim to fire on September 1, 1910. The Daily Bulletin lamented, "Rochester was visited by one of the most disastrous fires and one of the most stubborn to fight." Despite efforts of local fire fighters the blaze consumed the top two floors of the structure. Inadequate water pressure was partially blamed but the water department insisted the standpipe was full and both pumps were running at the time of the fire. Sufficient water pressure had long been of prime concern to the city's fire fighters. An article from 1883 described the trial of a steam fire engine located at the city's first fire station on July 4th. According to the editor, "a strong stream was thrown to the height of about 110 feet." The editor concluded that the test "showed that under normal circumstances the Rochester Fire Department can be relied upon to do good and effectual work."

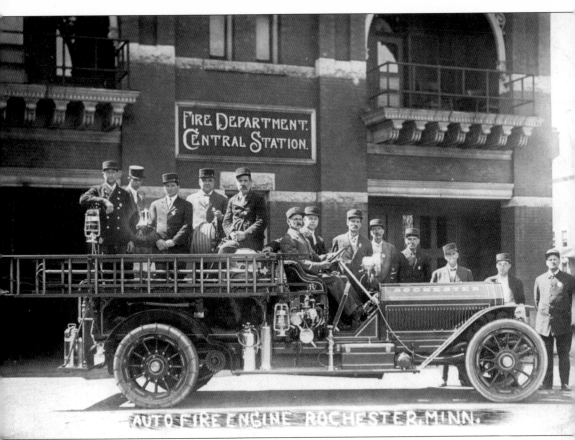

MOTORIZED PUMPER. In 1912 the Rochester Fire Department put into service its first piece of motorized equipment. This first fire truck was an American La France pumper. Equipped with a small pump, hose and a chemical tank, it represented the most advanced fire fighting equipment of its day. Other improvements had been made to the city's fire preparedness since 1870. An elevated water tower and a windmill pump were installed at Fourth Street SE and South Broadway in 1873 greatly increasing the available water pressure. A year later four underground cisterns were constructed to provide water for areas of town outside the range of the stationary pump. In 1886 a call box alarm system was installed allowing rapid communication with the firehouse and in 1887 eight miles of water main and 120 fire hydrants were put in place to augment Rochester's firefighting infrastructure. The city council had good reason to supply the fire department. Failure to provide capable fire protection was a deterrent to business investment in the community as fires were costly, disheartening affairs. When the Steven's House hotel burned on March 17, 1877, the *Rochester Post* reported, "the old Steven's House went up in a sheet of flame, and the next morning nothing was to be seen on the site of that pioneer structure but charred bits of timber, gaping cellar and crumbling stone walls. The sight was dreary, desolate and exceedingly unpromising."

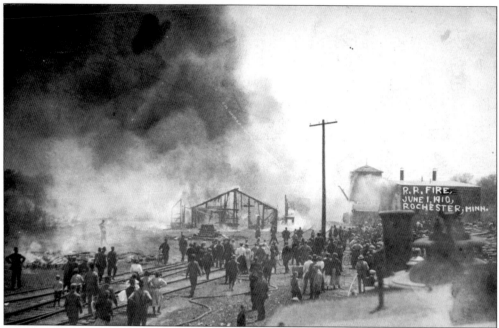

DEADLY FIRE. A howling fire at the Chicago & Great Western Stock yards on June 1, 1910, came exactly three months before the fire that destroyed much of Rochester's Central School. George R. Cole, a sheep shearer, was reportedly killed in the blaze after a night and morning of heavy drinking. Initially several other people were also feared dead. However an investigation found that all were alive and well elsewhere in the city.

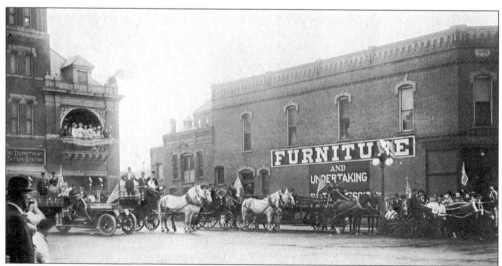

HORSE TO MOTOR. Both horse drawn and mechanized fire units are assembled at South Broadway and Fourth Street SW in this photo from July 4, 1915. The Central Station is at left and the R.L. Tollefson Building, housing P.F. Johnson Furniture & Undertaking, is at right. Two months earlier Rochester's Fire Department, under Chief William Letford, had become a full-time organization. On April 10, 1918 the city sold the remaining fire horses and became completely mechanized.

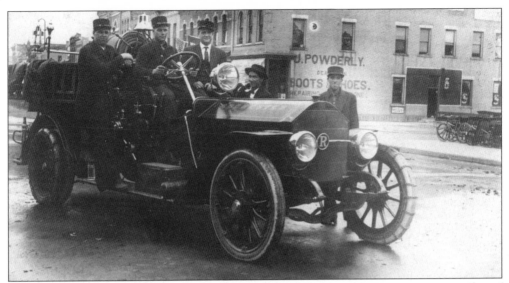

BY ANY OTHER NAME. In the early years of Rochester's organized fire protection, a number of hook and ladder companies came and went. Among them were such fancifully named units as the Alert Hook and Ladder, the Nighthawk Hose Company, the Third Ward Tigers, and The Sound Sleepers. These firemen, photographed on Broadway Avenue in about 1918, were known simply as members of the Rochester Fire Department.

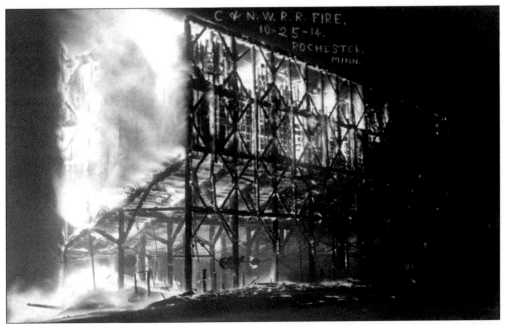

ALL ROCHESTER THREATENED. Described by the Rochester Daily Bulletin as, "spectacular in appearance, cruel and revengeful in its work of destruction, and a menace of danger to public buildings and of human lives," a massive fire on October 10, 1914 destroyed the Boler & Scanlan elevator as well as adjacent buildings and railroad boxcars. So fierce was the inferno that Rochester's fire department and citizens were kept busy extinguishing smaller blazes caused by flying embers.

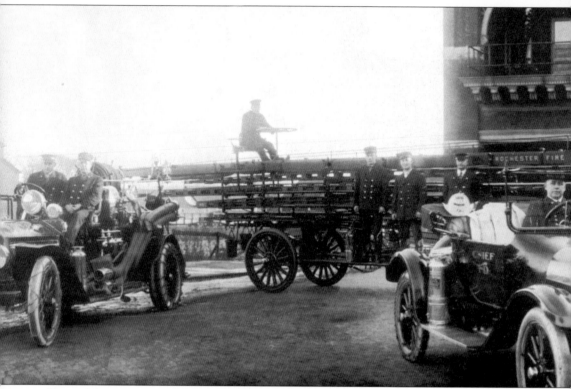

FULLY MOTORIZED. A fully motorized Rochester Fire Department is on display in this photo from about 1918. The 75-foot aerial ladder unit was purchased in 1917 in response to a need for better service for the multi-story buildings downtown. In 1918 the department reorganized

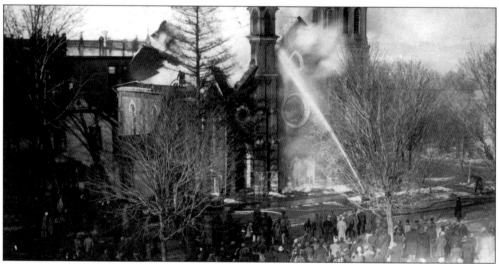

SPECTACLE. The Baptist Church is gutted by fire as firefighters spray the structure with water and a crowd of spectators looks on. Many Rochester churches experienced the same terrible scenes at some point in their histories. Spectacles of fire with their drama and tragedy have long been a great lure to photographers. Reporting on a fire in 1914 the *Rochester Daily Bulletin* remarked, "The camera fiends were in abundance to get a good picture of the beautiful scene."

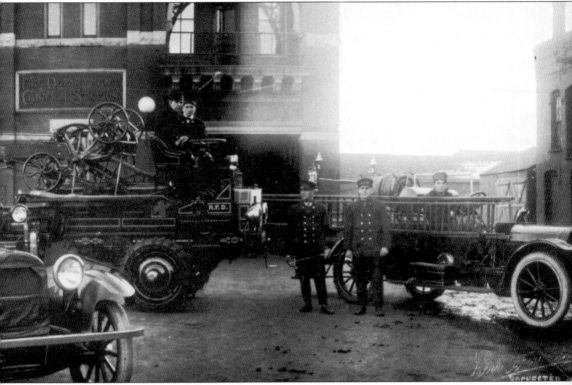

into a two-platoon system working one week of nights and one week of days. This system continued until 1934 when a schedule of 24 hours on and 24 hours off was adopted.

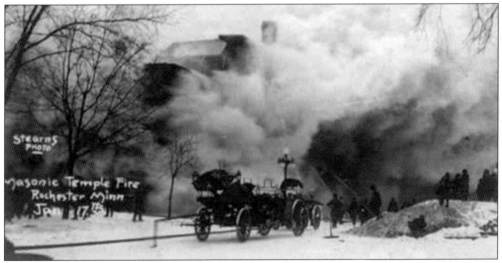

A DANGEROUS BUSINESS. Rochester's firefighters, or "fire laddies" as they were called at the time, battle a mid-January blaze at the Masonic Temple. Smoke, flames, heat, exhaustion, and even cold are among the dangers incumbent in the pursuit of a firefighter's duties. Rochester's volunteer and professional firefighters have put their lives at risk for the community's benefit in literally thousands of fires since the first ladder and bucket brigade was formed in 1866.

REDUCED BY FIRE. The historic Cook Hotel is reduced to three stories after a fire gutted the third and fourth floors on February 3, 1947. The building was further reduced to two stories in the spring of 1947 and was eventually razed in 1949 to clear the way for construction of a new Woolworth's Building. Later the Woolworth's Building was refurbished and renamed the Lanmark Building.

FOURTH CENTRAL FIRE STATION. Constructed at South Broadway and Sixth Street SW in 1930 at a cost of $50,000, the station boasted three pumpers, a 75-foot American La France Aerial truck and a Packard fire chief's car. Fire Chief C.E. Ginther oversaw 24 firefighters and three officers. The fire poles from the 1898 Central Station were re-utilized in both this 1930 station and the 1995 Central Station that replaced it.

Seven

THE THIRTIES AND FORTIES

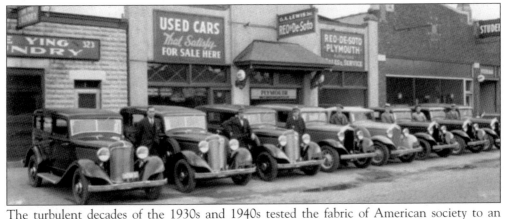

The turbulent decades of the 1930s and 1940s tested the fabric of American society to an extent that the country had not seen since the War Between the States. The stock market crash of 1929 ushered in a decade of economic depression that closed banks, ruined businesses and put millions of Americans out of work. In Rochester the same hardships were evident and yet the city enjoyed a number of positive events as well. Former Rochester attorney Frank B. Kellogg was honored with a Nobel Peace Prize. A new City Hall was constructed and the city made the most of Civilian Conservation Corps. and Works Projects Administration assistance to create and beautify Silver Lake and Silver Lake Park. Rochester received visits from President Roosevelt and accepted the Mayo's generous gift of the Mayo Civic Auditorium. The community also felt the loss of three of the city's medical pioneers, Sister Joseph Dempsey, Dr. Charles H. Mayo and Dr. William J. Mayo. The 1940s saw the end of the Depression but its struggles were replaced by the pain and apprehension of world war. A call for volunteers sent hundreds into the armed forces, and again Rochester contributed talented and dedicated doctors and nurses to the war effort. On the home front the people of Rochester did their part to support the troops including buying war bonds, collecting scrap metal and planting Victory Gardens. Ultimately the people of Rochester were able to celebrate a hard won victory in World War II and continued to strengthen and promote the city in the years following the war.

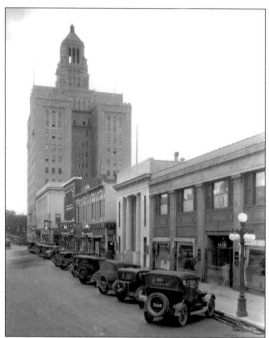

A Stroll Down Second Street. Half the buildings in this view of Second Street SW, looking west from Broadway in 1931, are now gone. From front to back are E.A. Knowlton & Co., the First State Bank of Rochester, the Brackenridge Building housing Lyman's and Thurber's Cafe, the IOOF (Odd Fellows) Building hosting Blickles Jewelry, the Masonic Temple with the Weber & Judd Drug Store, and the Plummer Building.

Cafés. A friendly "hello," a seat at the counter or in a booth, the latest from a newspaper or your neighbor, and a steaming cup of black coffee—these are the universal characteristics of the Rochester Cafés of the 30s and 40s. Among them were Vi's Café, the Princess Café, the Capital Eat Shop, Morey's Bar & Café, Kubat's Dinette, the South Crystal Café, and Black's Billiards & Café. Pictured is an early ad for the Grand Café.

HOLLAND'S MARKET. Ernest Holland started his grocery business in Rochester in 1907. In 1930 his son, Newton Holland, moved the business to the location pictured, next to China Hall at 216 First Avenue. The grocery was converted to a cafeteria in 1944 and sold to Leon Latz in 1958. A second story was eventually added to the building and it housed a succession of restaurants including the Bank Restaurant, Henry Wellington's, Newt's and the City Café.

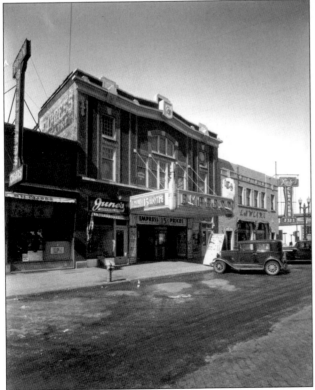

THE EMPRESS. Built in 1914 on a lot originally occupied by the former site of a livery stable and later a warehouse for the R.C. Drips Grocery firm, the Empress Theater is shown here next to the Lawler's Cleaners on the corner of Broadway and Center Street. J.E. Reid opened the ornate vaudeville and movie house also known as the Empress Billiard Parlor and Café. Once called "The Theater Beautiful" it closed in 1956 and was razed on December 31, 1965.

MOST FAMOUS. Shown here accepting the Nobel Peace Prize in 1930, Frank B. Kellogg is one of Rochester's most famous former citizens. A Rochester attorney for ten years, Kellogg was elected to the U.S. Senate in 1916, served as Secretary of State under President Coolidge and later as ambassador to Great Britain. In 1928 he co-authored the Kellogg-Briand Pact, which renounced war as an act of national policy. Sixty-three nations signed the pact.

SECOND CITY HALL. This art deco landmark was constructed at the same location as Rochester's first City Hall, which was razed in July of 1931. The building was occupied on June 1, 1932, during Julius J. Reiter's fourth term as Mayor. Mr. Reiter's political career was rather unusual. He served four terms as Rochester's Mayor, but never two terms in a row. He held the office from 1907–1909, 1917–1919, 1923–1925 and 1931–1935.

PARADE IN THE QUEEN CITY. An Elks convention parade files along Rochester's Broadway, *c.* 1933. The Queen City nickname was still active in the 1930s with the Queen City Café visible in the corner building at center. Other Rochester businesses using the name included the Queen City Candy Co., Queen City Feed Mill, Queen City Creamery, Queen City Silver Fox Farms, and Queen City Finance Co.

RESILIENT GOODWILL. The 1930s were a time of widespread hunger, joblessness, farm foreclosures, bankruptcies and general economic hardships. Still, in Rochester a helpful smile was never far distant as demonstrated by brothers Lyle and Tom Altorfer in 1935 outside their hardware store at 312 South Broadway. World famous polio expert, Sister Elizabeth Kenny noted the characteristic good will when she visited the city. "The whole city of Rochester," she later said, "seemed to exude friendliness."

WORKS PROJECTS. President Franklin D. Roosevelt's New Deal created numerous federal programs to get Americans back to work. In Rochester the Works Progress Administration provided jobs related to work on roads, bridges, and parks. Here laborers extract building stone from the quarry east of the State Hospital grounds in 1936. The stone was used in local works projects. The hilltop quarry later became part of Quarry Hill Park.

RELIEF AND STIMULUS. One of three bridges built in Silver Lake Park by Works Progress Administration workers in 1936. The extensive Silver Lake Park project involved over 800 men and included construction of the dam and Silver Lake. Also part of President Roosevelt's economic relief and stimulus plans Rochester had three camps for Civilian Conservation Corps workers in the 1930s. The first was established on June 24, 1933 with the others opening in 1934 and 1935.

KEROSENE-COOLING. A group of young women watch a demonstration of a new Electrolux kerosene refrigerator in 1937. "No Water, no electricity, no daily attention" claimed the advertisement. Jenson Hardware (later Ace Hardware) at 318 South Broadway sponsored the demonstration. The intense interest in the innovative kerosene-cooling machine might partially reflect the fact that the previous summer had seen the worst heat wave in Rochester's history.

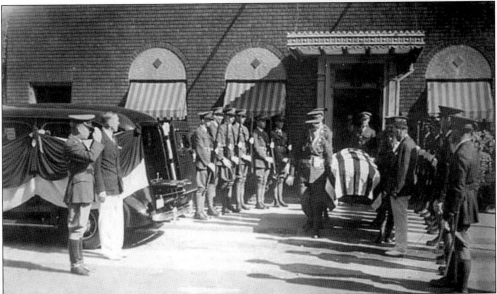

HONOR GUARD. A military honor guard stands by as the body of Minnesota Governor Floyd B. Olson is removed from a Rochester funeral home in 1936. Elected in 1930 on the Farmer-Labor ticket, he was a popular governor and was easily reelected in 1934. He was instrumental in gaining a law in 1933 that temporarily stopped farm foreclosure sales. Olson's death on August 22, 1936, marked the second time a Minnesota Governor had died in office while in Rochester.

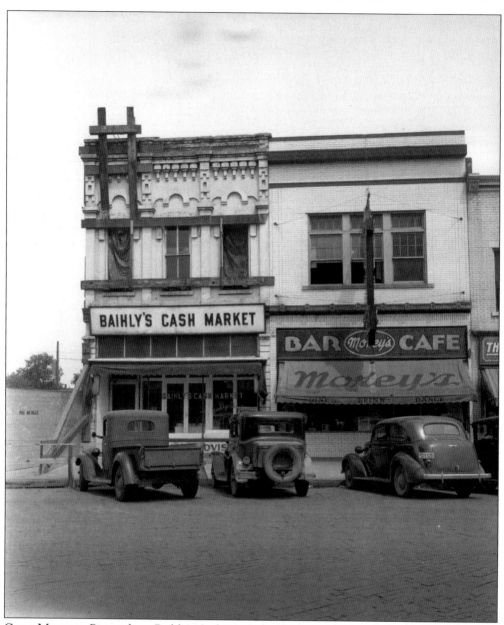

CASH MARKET. Pictured are Baihly's Cash Market and Morey's Bar & Café c. 1937. The wood bracing on Baihly's is due to construction for a new Montgomery Ward Store next door. The Baihly Meat Market was founded in 1858 by George Baihly and remained at its original location, 108 South Broadway, for 91 of its 95 years of business. The "Cash" part of the Baihly's Market name came about after the turn of the century. In 1918 the Rochester Daily Post reported, "Owing to various war conditions and the difficulties of getting competent and regular help, the Baihly Meat Market has decided to enter upon the Cash and Carry plan." Prior to this time Baihly's and other merchants delivered their products to their customers all over the city and often handled purchases 'on account'. The newspaper further noted, "with the urgent requests of the government to save in every possible way" Baihly's was proving itself a progressive business by adopting the system. At the time of it's closing in 1953 Baihly's was the city's oldest business.

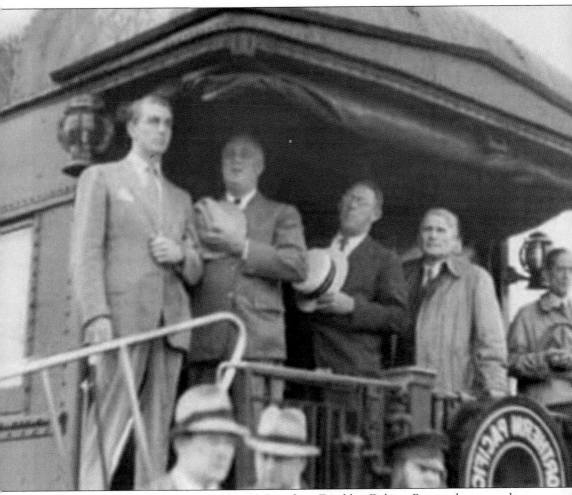

VISIT FROM FDR. In September of 1938 President Franklin Delano Roosevelt returned to Rochester to visit his son James who was being treated at the Mayo Clinic. War clouds had loomed over Europe for some time and on September 12 word reached FDR in Rochester that Adolph Hitler was making overt threats at expansionism aimed at Czechoslovakia. According to Harry Hopkins, Roosevelt's close advisor, the President immediately ordered a list of aircraft manufacturing sites. "He was sure then that we were going to get into war," wrote Hopkins later, "and he believed air power would win it."

The CBS Radio program, *March of Time*, aired this dramatization of the President's farewell in Rochester: "NARRATOR—From Cordell Hull to Franklin Roosevelt goes word that three more Sudeten districts have been placed under martial law. Czechoslovakia has called out two more reserve classes to the colors . . . 140,000 men. And a few hours later, on the observation platform of a train, drawn up in the station at Rochester, Minnesota, home of the famed Mayo Clinic, stands Franklin Roosevelt, his hands gripping the railing in from of him.

F.D.R.—My friends . . . here I came as a father and not as President, and you treated me accordingly. I am going away knowing that you still will be pulling for that boy of mine. PAUSE. I am not going back to my Hudson River home now but to Washington. For, as you know, conditions of affairs abroad are extremely serious. That is why I go back to the national capital, as President."

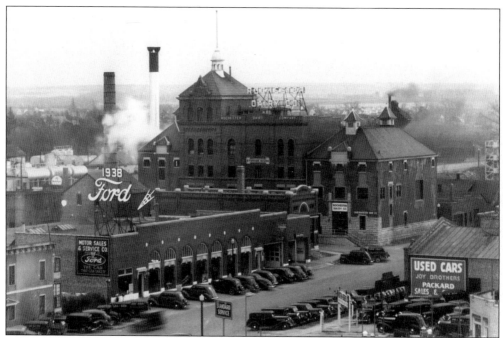

LOST VIEW. Believe it or not this is a view of First Avenue SW in 1938. The Ford Garage and Dealership pictured was located at 412-418 First Avenue SW. The expansive buildings of the Rochester Dairy Company, seen beyond the dealership and now missing, were originally the home of the Schuster Brewery. Established by Henry Schuster in 1850, the brewery produced beer prior to prohibition and near beer until it's closing in 1921.

MAGNIFICENT GIFT. "Dr. C.H. Mayo Gives Auditorium to City" declared a banner headline in the Rochester Post Bulletin on February 5, 1938. The Mayo Properties Association, headed by Dr. Will Mayo, also contributed to the project with the short-term goal of providing much-needed jobs locally, and the long-term goal of attracting cultural and sporting events to the city. "We have long recognized the fact that one of the urgent needs of our city is a public auditorium," wrote Dr. Charles.

A BOXING TRADITION. Rochester youths practice their boxing skills *c.* 1940. Mike Sternberg established a Golden Gloves program in Rochester in 1937 and for four decades amateur and professional boxing flourished in the city. In 1943 Mert Herrick became the first Rochester boxer to win an Upper Midwest Golden Gloves title, a feat he repeated in 1944. In 1949 a Mayo Civic Auditorium crowd of over 4,000 watched heavyweight champion Joe Louis defeat Orlan Ott.

THE HOME FRONT. The entry of the United States into World War II, in December of 1941, sent scores of Rochester men and women into the theatres of war. On the home front support was given through buying war bonds, rolling bandages, planting Victory Gardens, contributing to drives to collect metal, rubber, stamps, and more. Like "Rosie the Riveter" Rochester women filled jobs vacated by soldiers sent overseas.

CARRYING THE NEWS. Paperboys stand in the doorway of the Rochester Post Bulletin's building on First Avenue SW *c.* 1942. The news they, and others like them, carried during the 1940s was some of the soberest ever to greet Rochester readers. Casualty lists and daily war news filled the front pages for four long years. 326,000 Minnesotans served in uniform during the Second World War, of these 6,309 were killed or missing in action by wars end.

HEADLINES. "WAR BREAKS OUT" was the *Post Bulletin's* banner headline on September 1, 1939. The next few years brought many more, the Armistice Day Blizzard of 1940, the Japanese attack on Pearl Harbor and the U.S. entry into World War II, the long litany of war news, the Philippians, North Africa, losses in the Pacific, Sicily, Italy, Guadalcanal, D-Day. Perhaps the largest headline of the decade came on April 12, 1945—it read, "ROOSEVELT DEAD".

Eight

ROCHESTER
LOST AND FOUND

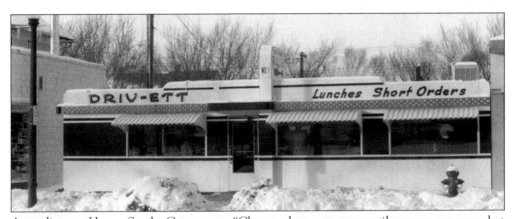

According to Henry Steele Commager, "Change does not necessarily assure progress, but progress implacably requires change." Rochester, Minnesota has been a place of both progress and change since its beginning in 1854. So much so, in fact, that little of the city's nineteenth century architecture remains. Even structures built in the first decades of the twentieth century are a bit hard to come by as the city continually renews itself. Among the many notable structures lost to progress or disaster are Rochester's first City Hall, Olmsted County's grand 1867 Courthouse, Two stately Rochester Post Office buildings, the original Second Minnesota Hospital for the Insane, all the city's early school buildings, the Mayo Clinic's 1914 building, a number of fine churches and two airports that once lay within the city limits. Also lost and unlikely to return are the passenger train, real 'full service' gas stations and the white nurse's cap, all of which were once common in Rochester. There are also mysteriously missing landmarks such as the statues once resident in Mayo Park and the Victory Arch whose exact location within Mayo Park is just as much a mystery as the time and reason for its disappearance. So few are Rochester's remaining historic places that those that do survive are all the more precious. Places like Calvary Episcopal Church established in 1863, the Chicago & Great Western R.R. Depot moved three times and now again in its original location on Fourth Street SE, the beautiful 1928 Chateau Theatre and famous local homes such as the Plummer House, Mayowood and the Foundation House.

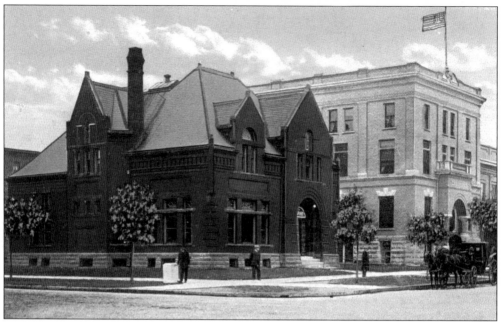

LOST: PUBLIC LIBRARY & Y.M.C.A. Located on the corner of Second Street and First Avenue SW, Rochester's first Public Library Building was built in 1898 at a cost of $15,000. The red brick structure housed 3,000 to 9,000 books. Sold in 1936, profits from the sale of the property were put towards the Mayo Civic Auditorium in 1938. At right is the Y.M.C.A. building. Built in 1906, it was razed in 1938.

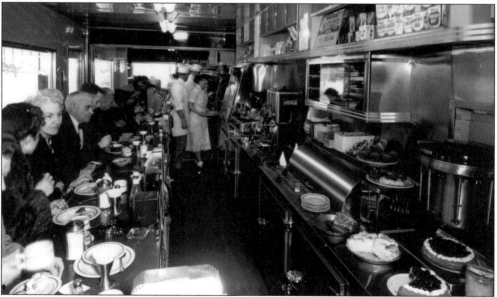

LOST: THE DINER. The Diner holds a nostalgic place in the lore of popular culture. Introduced before the fast food revolution began in 1948, diners like The Driv-ett Diner, across from Saint Marys Hospital, served up hot food and coffee in an elbow-to-elbow environment reminiscent of the old train dining cars. In 1939 Rochester residents could get a "delicious noon-day luncheon" at the diner of their choice for "35 cents and up."

FOUND: THE PLUMMER BUILDING. The most noticed of Rochester's historic landmarks, the Plummer Building is rich with intriguing features. A fanciful Romanesque and Moorish Gothic style is evident in the nineteen-story structure. Carved stone reliefs of medical symbols, mythological characters and Minnesota wildlife, as well as griffons, gargoyles, nurses, owls and unicorns are all found high atop the tower, which was specially designed to house a carillon that has grown into the most complete in North America.

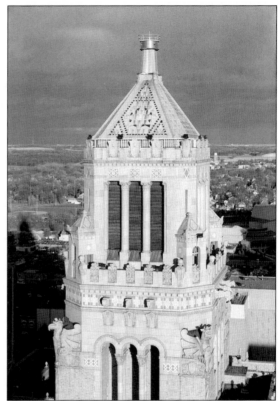

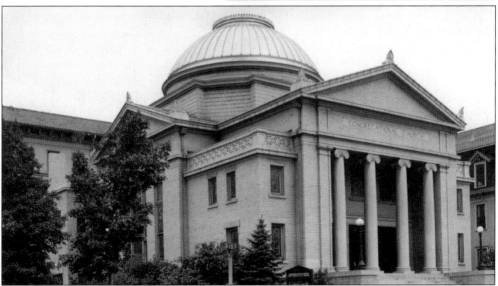

LOST: CONGREGATIONAL CHURCH. This impressive church, built in the classical style by G. Schwartz & Co. in 1916 was the second Congregational Church built on this site across Second Street from the Central School building. The first church was begun in July of 1863 but completely destroyed by a spring 1864 tornado before completed. The work began again and the church held its first service in December of 1864. The 1916 structure pictured was demolished in 1963.

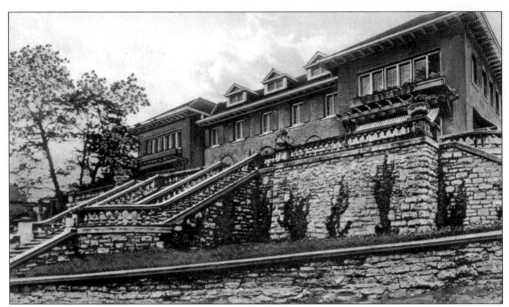

FOUND: MAYOWOOD. Home to three generations of the Mayo family and now maintained by the Olmsted County Historical Society, Mayowood was built by Dr. Charles H. Mayo in 1910–11. Charles married Edith Graham, daughter of Dr. Christopher Graham, in 1893. Charles and Edith raised eight children in the 55-room Mediterranean-style mansion. The 3,000-acre grounds featured a greenhouse, outbuildings, eight farms, a track for harness racing and a manmade lake complete with hydroelectric dam.

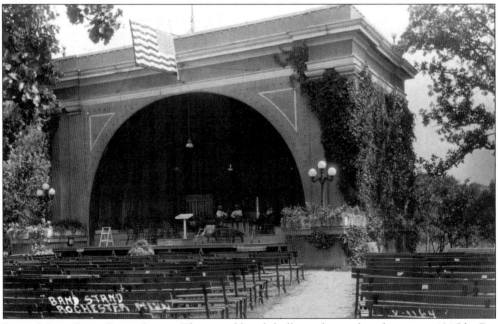

LOST: MAYO PARK BAND SHELL. This grand band shell was donated to the city in 1915 by Dr. William J. Mayo to replace the small hexagonal bandstand, which had long stood in Mayo Park. Some 2,000-park benches were provided for orchestra concerts and other events. The structure was torn down in 1951 to make way for a memorial to Drs. William J. and Charles H. Mayo.

LOST: STATUES. This statuary park was located in a portion of Mayo Park approximately where the 1995 Rochester library was built. Not only is the statuary area gone, but also the statues themselves are unaccounted for. The fate of other lost Mayo Park fixture's is not so mysterious however. The park's Civil War cannon, purchased by local patriots in 1861 and returned to Rochester after the war, were lost to a scrap metal drive in 1943.

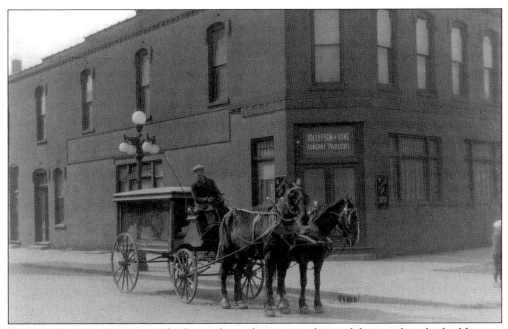

FOUND: FUNERAL PARLOR. The horse drawn hearse is a thing of the past but the building on the SW corner of Fourth Street and Broadway, which in 1916 housed the Tollefson & Vine Funeral Parlors, is still there. Built in 1879, the structure has held numerous businesses. The Vine name is still to be found as well, with the Vine Funeral Home in Rochester advertising, "Quietly there when needed since 1879."

LOST: VICTORY ARCH. The victory arch pictured has been missing from Mayo Park so long that it has become unclear as to where in the park it stood. Also missing from the park are the island that once lured young couples in canoes to its shores, the footbridge and bath house, and the little zoo that from 1911 to 1941 held everything from fox and a raccoon to bears, a buffalo wallow and a monkey cage.

LOST: THE PRINCESS CAFÉ. Known for its homemade ice cream and well-stocked soda fountain, the Princess Café was operated for over 50 years by the Margellos family in a building built by Harry and Christ Margellos in 1921. First established as a café and candy company, the business abandoned candy making during World War II due to sugar rationing. The building at 14 South Broadway was razed in 2003 to make way for a high-rise.

FOUND: SECOND PUBLIC LIBRARY. Renowned Rochester architect Harold Crawford designed Rochester's second Public Library building, which was constructed at a cost of $178,000 at the corner of Second Street and Third Avenue SW. A Public Works Administration grant paid for 45 percent of the building costs and the Mayo Properties Association provided the land. When completed in 1937 the building had a capacity of 75,000 books, a big improvement over the first facility. However, in the late 1960s the library was again experiencing growing pains and in 1972 moved into the former J.C. Penney building at 11 First Street SE. The building on Second Street reverted to the Mayo Clinic, which in turn contributed generous funding toward the purchase of the library's new building. The 1937 building was constructed of dolomite limestone quarried at Kasota, Minnesota and was built in a Tudor-Gothic style. Known as the Mitchell Student Center since 1972 and used as a learning resource library for the Mayo Medical School, the building has been enhanced with details such as bronze doors bearing literary and scientific designs. The building's designer, Harold Crawford, was responsible for a number of elegant Rochester and area buildings including the 1930 Fire Hall on South Broadway, Folwell School, the 1932 City Hall, the Rochester Bread Co. building, the 1928 Lanesboro Community Building, the Eyota Cooperative Creamery and many more. Mr. Crawford also designed a number of the stylish homes in Rochester's exclusive "Pill Hill" neighborhood.

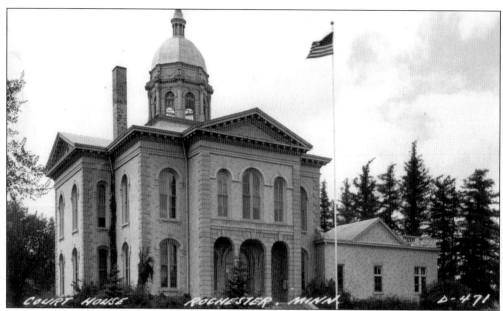

LOST: 1867 COURTHOUSE. Built in 1867 the Olmsted County Courthouse was spared the wrecking ball until 1958. A section of the courthouse's dome was sent crashing through the roof during the tornado of August 21, 1883. A statue of the Lady of Justice was added to the top of the dome in 1892 where it stood until the building's demise. The statue can now be found inside the courthouse built in 1993.

FOUND: THE CHATEAU THEATRE. Pictured here during a Depression-era "Dollar Days" sales event, the Chateau Theatre was designed by Ellerbe architects and built in 1928. The theatre was both movie house and vaudeville stage. Tallulah Bankhead and Tom Mix were among the stars that trod the theatre's boards. The theatre, whose most remarkable feature was always its French Medieval castle interior, complete with twinkling night sky, has been preserved as a Barnes & Noble bookstore since July of 1994.

FOUND: AVALON HOTEL. Built in 1915 it was first a kosher hotel for Jewish travelers run by Sam Sternberg and called the Northwestern Hotel. In 1939 establishments catering to Jewish travelers included Levy's Hotel at 105 Second Avenue NW, Madenberg's at 20 First Avenue NE, and Ginsburg's Kosher Restaurant at 213 First Street NW advertising, "the oldest and leading Jewish dining rooms in Rochester." In the 1940s the Northwestern Hotel was renamed the Avalon Hotel and operated by Vern Manning. Due to racial discrimination and intolerance throughout the 40s, 50s and 60s, the Avalon was the only hotel available to blacks visiting the city. Famous musician Duke Ellington and boxer Henry Armstrong both stayed at the hotel. The Avalon eventually became a focus of local civil rights activities like Rochester's first, ill-received, civil rights march on August 23, 1963. On that day 38 marchers walked from Silver Lake to Soldiers Field in a show of support for racial integration and equal rights. The march was marred by white teens that hurled eggs at the marchers from rooftops and shouted insults. Later that day a burning cross, the age-old symbol of racial intolerance, oppression and hatred, was thrown in front of the Avalon Hotel by a group of boys. "Let's have no more civil rights marches in Rochester," advised an editorialist in the local paper a few days later. The marches and the Civil Rights movement continued however, with gradual but extensive and positive change the result. The Avalon closed its doors years ago but the building still stands on North Broadway.

FOUND: THE ARMORY. Built in 1915 in a classic medieval fortress style, the exterior of the Rochester Armory has remained virtually unchanged. The building is located at 121 North Broadway where it has been a visual pleasure to generations of local citizens and visitors. Now a Senior Citizens' Center, it has been called one of Rochester's "most successful examples of the adaptive re-use of a historic structure whose original function became obsolete."

LOST: THE FULL SERVICE STATION. In post-war America, with automobiles occupying more of the national psyche than ever, service was king. For 20 cents a gallon, and without leaving his or her car, a motorist at this Rochester Conoco could expect promptly pumped gas, washed windshield, a test of the tire pressure and a look under the hood to check the oil and fluid levels, and all with a smile and free roadmap to boot.

LOST: STATE HOSPITAL.
Described as "looking like a typical college 'Old Main'," the entrance building of the Rochester State Hospital was constructed in the 1880s and torn down in the summer of 1964. Thousands passed beneath its high tower during long decades when such institutions often lagged shamefully behind their medical contemporaries in the fields of medicine, psychology and psychiatry.

FOUND: PAINE'S FURNITURE. Note the sign for Paine's Furniture near the center of this photo from the 1930s. This stretch of historic buildings, dating from the 1870s to 1890s, still stands along Broadway Avenue South. Even more remarkably, Paine's Furniture, founded by Cedric Paine, still occupies the 1879 Olds-Fishback Building at 311 South Broadway just as it has for over 90 years.

LOST: THE GRAHAM ESTATE. William D. Lowry built the original brick structure in 1855–56 at 813 Third Avenue SE on what was then a patch of land along the Dubuque Trail. The home was purchased from the Lowry family in 1872 by Walter Lowry Brackenridge, a relative and prominent early attorney in Rochester. Mr. Brackenridge's daughter Blanche married Dr. Christopher Graham, one of the original partners in the Mayo medical practice, and the two took up residence in the house following Mr. Brackenridge's death in 1905. In 1910 Dr. Graham purchased 160 acres of land adjacent to the Brackenridge property in SE Rochester. The doctor retired in 1917 and over the next two years he and his wife expanded and transformed their stately home drawing upon a Georgian design. In 1919 Dr. Graham, who had a keen interest in agriculture, granted the Olmsted County Fair Association a permanent lease to the land that now constitutes the county fairgrounds. During his retirement the doctor became nationally known and respected as a cattle breeder and successfully made the grounds of the estate a showplace of gardens, orchards, pools and colorful foliage. Dr. Graham donated or otherwise disposed of more of his land before his death in 1952 at the age of 96; however, as late as 1967, 23 landscaped acres still surrounded the elegant Graham Estate.

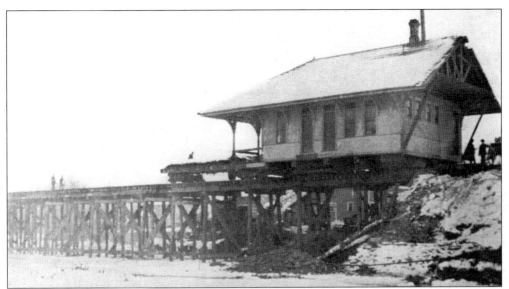

FOUND: THE TRAVELING DEPOT. Built by the Winona & St. Peter R.R., which became the Winona & Western R.R., the depot pictured was moved on flat cars to Second Street SE in 1903 after the C. & G.W. R.R. purchased the W & W R.R. It continued as a train station until 1949 and was a bus depot until 1987. Saved from destruction and moved to temporary quarters twice in the late 1980s, the structure was restored to its original site in 1997.

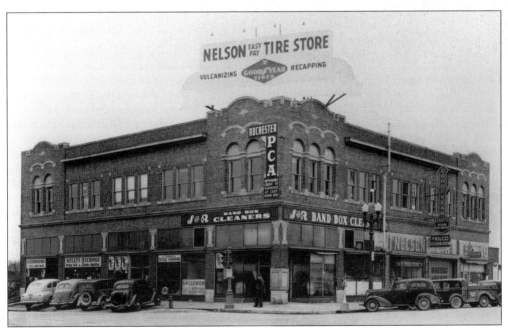

FOUND: RIVERSIDE BUILDING. Built in 1918 on the SE corner of Fourth Street and Broadway Avenue, the structure has long been a commercial building. The old millrace carried water from Strawberry Dam, near Soldier's Field, under the building prior to a 1978 renovation. The 16-foot waterfall on the Zumbro River, which inspired Rochester's name, was nearby until 1932 when the City Council deemed it a hindrance and had it removed.

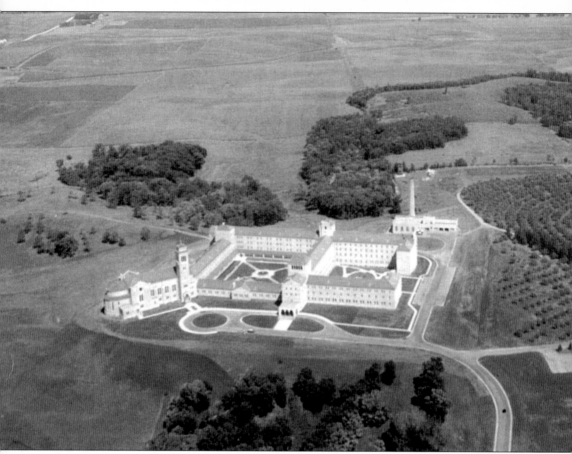

LOST: FARMLAND. Pictured is Assisi Heights, motherhouse of the local Franciscan Sisters, shortly after its construction in the early 1950s. Patterned after the Basilica of St. Francis in Assisi, Italy, the 1,000-bed facility was originally surrounded by open farmland with the city of Rochester lying largely to the south and east. When completed, Assisi Heights included seven buildings, with its own laundry, garage, and power plant. The west wing was established as an infirmary for the care of the order's most aged and ill members. The northwest wing housed retired sisters in good health and a school for Initiates. The lower floors held the kitchens, cafeterias and other common rooms, while the center wing housed the order's community college. Administrative offices filled the single-story southeast wing. Assisi Heights still resides on this hilltop in Northwest Rochester, but half a century of expansion has seen the city grow up around and far to the north of the motherhouse and the farmland has been filled with sprawling neighborhoods as the busy city of Rochester continues its restless advance into the future. In 1874 a publication by A.T. Andreas boasted of Rochester, "it will be difficult to find another new town with so many attractions within and around it, so kind and hospitable a people, so much that makes home comfortable and life enjoyable, as this little city in the interior of a new state on the frontier of a new country." Today the state and country are not so new, but the little city of Rochester is still the kind of place where comfort, enjoyment, and hospitality are all easy to come by.